3488

D1409280

3488

DRAWING FOR FUN

Also by Alfred Daniels

PAINTING AND DRAWING

DRAWING FOR FUN

ALFRED DANIELS

Doubleday & Company, Inc., Garden City, New York

1975

Library of Congress Cataloging in Publication Data

Daniels, Alfred
 Drawing for fun

 1. Drawing—Instruction. I. Title.
NC730.D27 741.2
ISBN 0-385-01543-7
Library of Congress Catalog Card Number 74-25100

CONTENTS

<div align="center">CHAPTER 8</div>

PENS AND BRUSHES 149

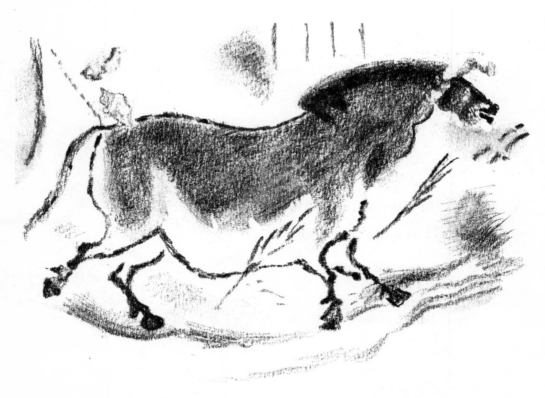

FIG. 1. Study of an animal from the walls of the Lascaux Caves, France.

CHAPTER 1

INTRODUCTION –
AN APPROACH TO DRAWING

Can drawing be made simple? Of course it can, and for a very good reason: because drawing is natural.

The urge to draw or paint has been with man since earliest times. And he has always tried to fulfill it, come what may. It is one of the most direct forms of expression known to man.

In the caves of Lascaux in France—some ten thousand years ago—primitive man drew. Before he could invent tools, build a shelter, farm or write, he drew. With the simplest forms of material—fat combined with pigment—he covered the walls of his caves with the most astonishing drawings of animals (Fig. 1). These drawings are so fresh and lively they look as "modern" as if they had been done yesterday. And they have a perception that we—with all our sophistication and progress—would find hard to equal.

Children, too, have this perception. They take to drawing easily and naturally; and even before they are given pencil and paper they make rudimentary drawings merely to occupy their hands. It is their way of learning to use them. They have a natural predilection to make marks—as many a clean wall will testify! They love to make marks in the dirt with their fingers; they like to scratch with sticks.

Let us examine the nature of this instinct. Children draw with complete unself-consciousness. They are absorbed and happy, and it is as if they have an innate gift and fulfill it in the best way they know. *The secret is that they are more concerned with the process than with the end product.* They are quite unconcerned with what adults say about their work. They are indifferent to criticism. They like to go their own way, and follow their own instincts without interference.

Because they do not need to achieve anything, they rarely compare their work with each other. And so they are not made to feel awkward or inferior when what they do isn't up to much.

Edgar Degas, the great French artist and perhaps one of the finest draftsmen of the last century, said, "Art is not a sport!"

In this laconic fashion, Degas summed up all the things that are so constricting to any potential artist. The very thought that you are out to compete with someone can freeze all your desire to begin, and once you've begun, it can frustrate all you wanted to do.

It also sums up the basic difference between the child's and the adult's approach to drawing.

Adults find it difficult to adjust to the idea that they are *not* in competition with anybody, whether it be Michelangelo, Rembrandt, or the man up the road who paints on Sundays. The fact that an artist like Picasso seems a more proficient draftsman than we are is beside the point. The fact that Leonardo and Rubens were geniuses has nothing to do with it.

Somehow, during our adult life we clutter up our minds with fears that need not exist. It is these fears that make drawing seem complicated. They prompt us to believe that we will never be able to draw and that we would be wasting our time if we tried.

But these fears are groundless. As we have seen, drawing is instinctive—as instinctive as breathing or walking. When we were children we did not forget to breathe or walk. We would have been severely handicapped if we had. These actions are vital to our physical needs. We practiced walking, for example, until we could do it without thinking.

But the natural ability to draw which we had from birth was a different matter. It was concerned with less pressing physical needs. Consequently, after the age of ten, when the pressures of life began to demand more and more of our time and energies, we were forced to let this ability grow stale.

When we grow up and those pressures are lessened and the desire to draw reasserts itself again, we find that the gift has grown a little rusty. We feel cheated and don't know why. We should be able to take up this skill where we left off, but often the effort to get the wheels turning again is too great. The help we may get or the advice we listen to generally makes it seem more hopeless. So we don't try. Or, if we do, we get easily lost and give up too soon.

This is what, in part, this book tries to do: to help a rusty gift start working again. And most of what is discussed here is aimed toward that end.

Relearning to draw must be tackled with enthusiasm and without strain. Anything that has to be achieved at the expense of pain cannot be the right way of going about it. A drawing that has been sweated at through clenched teeth cannot give anybody any pleasure—least of all the artist concerned.

Acknowledgement of one's limitations and working within them can have satisfying results. The world of art has known many talented artists who have failed to recognize this. In attempting too much, in desperately trying to live up to an impossible ideal (great art, mighty works, and so on), they succeeded only in producing empty imitations and insincere copies, which bored everyone—including themselves—until finally, embittered, they have faded away.

On the other hand, those artists who have accepted themselves and have been content to follow their own potentialities, unafraid of the accusation of being in a rut, have found their places in the history of art by not competing. And their work, when placed beside that of the truly great artists, compares very favorably.

These artists may have taken up art as a sideline first, being too modest to intrude wholly into the world of art—artists like the French customs officer Henri Rousseau, for example, the first of the "Sunday painters" to achieve world renown; or Morris Graves and Horace Pippin in America today (as well as Grandma Moses, who not only had fun, but made a modest fortune at the same time!). There are many of them, some well known, others not so known.

Then there are the full-blown professionals who are equally modest and who are often derisively termed "minor": Chardin and Watteau in eighteenth-century France, Fra Angelico and Pisanello in fifteenth-century Italy, William Blake and Samuel Palmer in nineteenth-century England. The list is endless. They all worked on a "small" scale, without pretensions. They hold their own with the giants. They are, if the truth were known, necessary counterparts.

But one question still remains: What is a "good" drawing? What is the standard by which all great drawings are judged? And if there is a standard of good drawing, how can we decide what it is so that we can use it to help us and not inhibit us?

All great drawings, past and present, must have something that puts them far above the natural but immature scribblings of a child. What that quality is, and its usefulness, is another aspect that this book discusses.

When we can recognize that quality in our own work, we shall be able to enjoy to greater advantage the works of others.

Therefore, I have attempted to uncover all the different aspects of good drawing, using many examples and diagrams, so that this quality will be revealed. From this discussion you will, in turn, be able to discover what is relevant to you, and to discard what isn't.

No matter how you look at it, you will be getting, so to speak, two things for the price of one: the pleasure of looking at the drawings of others and the pleasure of doing your own.

Lastly, a word about the materials you will use.

Drawing is a practical activity. As well as using your mind, your emotions, and your eyes, you will be using your hands. And your hands will use brushes, pens, pencils, crayons, and chalks.

You will also be using papers, sketchbooks, inks, and water colors (for washes). These materials will play a large part in the making of your drawings, and if properly handled, will contribute to the enjoyment of drawing that you will undoubtedly have. All the most important items have been listed, with detailed explanations of how to use them in their appropriate sections. These explanations are only for your guidance, however. It is more than likely that you will make many more discoveries in addition to those listed.

Simple exercises have been devised to familiarize you with materials. They have also been designed to bring your latent ability to life again. They are arranged to encourage the faculty of observation to become clearer and more perceptive. All these apparently separate activities are, in fact, conspicuously linked. You can't do one without the other. Naturally, a little patience and a little self-indulgence are required while you familiarize yourself with making the hand obey the mind and eye.

But there is this difference between drawing and the other arts—music, for instance. While in music each step can be a chore, each exercise a series of dreary scales, in drawing, each exercise, each step, each bit of practice is a thing in itself. Each step produces a piece of work that you can keep, show, or throw away, just as you like. Though considered as an exercise, each sketch can still be retained as the real thing: an exciting drawing, because each exercise has its own excitement and discoveries.

When you practice on a musical instrument, a study more often sounds like a study, but a draftsman's sketch or study usually has something that is important or exciting—either to the artist himself or to a spectator. And one of the best reasons why any artist draws is because it *is* simple—a simple way to study, for example.

Everything about drawing is simple because the materials are simple. They are certainly less complicated to handle than those of oil painting, water colors, tempera, or mosaic. And because of its simplicity, drawing has always been used as a basis for any training in art. It is the simplest way to come to grips with the complicated problems of visual perception, design, and creation generally—as we shall discover. Drawing opens up the mind.

Before embarking on any large project like a mural, a piece of sculpture, stage decor, or even a building, an artist will invariably first put his ideas down on paper in the simple framework of a drawing.

Film and television producers use drawings extensively when formulating how a program will look on the screen.

A simple drawing can do what hundreds of words would be inadequate to do. As an old Chinese sage once put it: "One picture is worth a thousand words."

What could be simpler than that?

MATERIALS

PENCILS AND PENS

Pencils and pens are the commonest types of writing implements. They are also the commonest in use for drawing. The Greeks seem to have considered writing and drawing as essentially the same process, since they have used the same word for both. But as far as artists are concerned, there is a world of difference between them. It is a serious mistake to think that any old pencil that writes is good for drawing. What will do for scribbling a note to the milkman will not necessarily do for a drawing. And an expensive pen that can make letters to friends more exquisite might be worse than useless for drawing.

Pencils and pens come in different grades and sizes. An HB lead pencil is quite different in character from a 5H or a 3B, even though they look alike and are more or less made in the same way. So we would do well to examine them further, in detail.

PENCILS

Lead Pencils. The name pencil originally applied to a small, fine-pointed brush and is still used to define the better sables used for water colors. Nowadays it generally means any sort of marking substance encased in a rod of wood for ease of handling.

Those pencils commonly called "lead" pencils are not made with lead at all. The outside is made of good cedar wood which is usually polished, and the marking substance is made with graphite. The graphite is mixed with clay and baked; it is the proportion of graphite to clay that determines the degree of *hardness* or *softness* of a lead pencil.

Hard and Soft Lead Pencils. The *hard* pencils are graded in numbers together with the letter H. This is indicated on one end of the pencil and *should never be sharpened off*. It is the only means you have of knowing exactly what grade of pencil you are using.

The numbers usually go from 2 to 6; 6H is the hardest, and H is the least hard.

The *soft* pencils are also graded in numbers, only these are followed by a letter B, 6B being very much softer than B. The letters HB denote the medium grade between the two extremes. HB is most favored for writing. It is usually the commonest grade on sale.

The hard pencils, ranging from H to 6H, give a clean, gray, fine line. The pencil point keeps sharp for a long time. But a great deal of pressure is needed to make the line dark, and the sharp point inevitably digs ridges in drawing paper, making the surface of a drawing look unpleasant.

Because of its qualities, the hard pencil is mostly used by architects and draftsmen for drawing plans and elevations. Engineering draftsmen use it for tracing and so on, where accuracy is needed, but it is much too inflexible for use in drawing. Anyone who has inadvertently drawn with a hard pencil will know what I mean. They are well named. They make drawing "hard."

Soft pencils are better than hard ones for drawing; therefore, make your choice from grade 2B and upward.

Yet they are not really the best drawing mediums and when you have experimented with others and learned to control them, you will wonder why you ever thought lead pencils so necessary.

First, *you must use a good soft pencil*. A cheap one will not do. Second, the quality and kind of paper you use will affect the marks you make. A smooth paper will make a soft pencil seem like a hard one. If the paper is too rough, the pencil will barely be able to make a delicate mark and a pencil drawing depends on its delicacy of touch. You can't be brutal with it. If you overwork the drawing so as to make a good rich dark, it will take on a very unpleasant shine.

A pencil drawing is so delicate that, to avoid smudging it while drawing, it must be protected either by the use of a fixative (discussed later in this chapter) or by a piece of clean paper over the parts that have been completed.

Pencil lines are easy to erase. But this is no real advantage to the unpracticed draftsman. Though some very fine drawings have been done with a soft pencil by many great artists, it is not the best medium for a beginner.

Carpenter's Pencil. There is another kind of lead pencil which is known alternatively as a *carpenter's* pencil or a *chisel* pencil. It has a flat wooden case and a flat graphite center, and when properly sharpened it draws with a thick, even line, rather like the mark a Conté stick makes (Fig. 2). It is used primarily by layout artists, who find the thick even line serves their purpose for quick, effective sketches and briefly expressed ideas. But for a straight study, the chisel edge of the graphite can be a limiting factor, and these pencils usually only come in one grade: medium.

For those who haven't drawn for a long time, it would be better to begin again with a *carbon* pencil.

Carbon Pencil. Carbon pencils can be bought just as lead pencils can and are easily recognized by their dull wood finish. The grade is marked on one end as on a lead pencil, but there are no numbers to indicate the hardness or softness. Instead, there are the letters B, BB, BBB for a soft degree, and H, HH, HHH for a hard one.

Carbon pencils give a good rich black; when they are used delicately they give a gray similar to that of a lead pencil. They do not shine, but have a dull finish, called matte. They sharpen to a fairly good point, but must be kept constantly sharp. They can be used on most papers, whether rough or smooth, and combine very well with water-color washes.

Carbon pencils have a wider range of tone than lead pencils and can be gradated as easily, but, unlike lead-pencil marks, the lines of carbon pencils are difficult to erase. This is the only disadvantage to overcome. Once this has been done, the advantages of using a carbon pencil are enormous:

1. It is easily fixed.
2. It doesn't smudge.
3. It produces a *positive* statement.
4. It is pleasant to use and not too difficult to handle.
5. The results are also pleasant to look at.
6. It is fairly clean to handle.

In many respects carbon pencils are not dissimilar from Conté crayon.

Conté Crayon. Any black, red, brown, or white pigment, bound with glue or wax, then made into short square sticks (Fig. 2) is usually referred to as Conté crayon. When this pigment is made into pencils, they are called Conté pencils.

Conté, as the crayon is usually called, is delightful to draw with and gives very pleasing results, but it was well known long before it got its present name.[1]

FIG. 2. Conté crayon sticks.

[1] Although Nicholas Jacques Conté gave his name to this delightful crayon, in fact, he was the inventor of the lead pencil. For the record, lead pencils did not become widely used until Conté invented them in 1799. The drawings that had a similarity to pencil work before that time were probably executed in "plumbago," which was not very popular as it was difficult to handle.

Before that time it was sometimes known as *sanguine*. Michelangelo, Raphael, Titian, and others of the Renaissance used it constantly.

Conté crayon is best bought by the box rather than in single sticks, as it is rather brittle and the box will protect it. Though it gives a firm line and an exquisite range of tone, it is rather messy to handle unless a proper holder is obtained. If you use it without a holder it will make your hands dirty and sticky. If you drop it, it will break. A holder, therefore, is vital.

There are usually two kinds of holders. One holds a single stick and the other type holds two sticks, one at each end. These holders are invariably made of metal—brass is the most common (Fig. 3). Brass holders are pleasantly heavy to hold and are usually perfectly balanced. The advantage of having a holder with double ends is that you can use two different colors readily. Another advantage is that since Conté is brittle, the points don't remain sharp for long; therefore, by having another stick ready, you will have another sharp point available for uninterrupted drawing.

FIG. 3. Conté double crayon holder.

For those who find the sticks a little awkward, the crayon made into pencils will be adequate. The only disadvantage here is that they don't last long. They are more wasteful to sharpen than the sticks because they break more often. Also they cannot make the delightful variety of marks that the sticks, with their square ends, can.

One of the great advantages of Conté is that on tinted paper the range of tone can be increased by the addition of white crayon or chalk. And though you can draw with carbon and chalk in a similar fashion, it is Conté crayon, with its smooth, flowing line and tone, that gives a richer effect.

As a loose distinction, you can say: *Use carbon for white paper, Conté (with the addition of white) for tinted paper, and lead pencils as rarely as possible.*

Lead, Conté, carbon, and charcoal, are the four classic drawing mediums.

Charcoal. Charcoal, like Conté, comes in stick form as well as pencil form. It is made in hard and soft grades, and in thin and thick sticks. It is possible to buy charcoal by the box, and you can buy boxes which contain all the grades and sizes (Fig. 4).

FIG. 4. Charcoal sticks.

Charcoal in stick form is a very sympathetic and flexible medium. It is easy and delightful to use. It can be erased quickly but is not rich in tone and cannot be overworked. If it should become overworked it is fairly simple to brush it off and begin again, with just enough drawing left behind as a basis for continuing.

The main advantage of charcoal is that it is a quick way of putting down large areas of tone effectively, but because of its limited range it can too easily become muddy and dirty if it is worked on too much.

Charcoal in stick form is fragile. The charcoal pencils are more robust, but lose some of the qualities that the sticks possess.

1. They do not erase so easily because the charcoal has been compressed.
2. There is a loss of fluidity in the marks they make.
3. They cannot cover large areas quickly.

There are also on the market various types of water-color and wax pencils, pastels, and wax crayons, which can be experimented with later—they will make a pleasant addition to the mediums you can use—but aren't particularly important to know at the beginning.

Pens. Pens, though useful for writing, are not the best instruments for drawing. They are too inflexible. They are rather like a hard pencil—hard to use. And even the proper, springy drawing nibs have a habit of being perverse; you need a great deal of patience and manual skill before you can get the best out of them.

Pens need a great deal of care, as well. Clogging, bending, and breaking occur frequently. Finally, the type of ink that is used has a great bearing on what

a pen can do. Inks vary and so do pens. What suits one type of pen won't suit another—which is all very complicated for a beginner. Therefore, I have left a fuller discussion of pens to a later section.

There is a fond belief that when you begin drawing you can happily start right away with a pen because, like a lead pencil, it is so convenient to carry. You will be disillusioned if you do. This applies equally to ballpoint pens (and fountain pens), however expensive they may be.

Felt Pens. There are, however, drawing pens on the market that go under the name of *felt* or *marking* pens. These are not really pens at all. "Fountain brushes" would be a more apt description of them because they make a line more like a brush than a pen.

Felt pens (one brand name is Flowmaster; there are others) look like large fountain pens. They consist of a container for holding the quick-drying ink (mainly brown or black), but instead of having a nib at the end there is a piece of felt, which is inserted in a slot. The ink suffuses the felt and is controlled by a valve. The felt makes a pleasant, thick mark. These felts come in various shapes and sizes and are interchangeable. You can get square-ended, chisel-ended, small, or large felts.

Felt pens can be used with confidence. They are practical, draw easily, and are ideal for outdoor sketching (Fig. 5).

Fig. 5. Felt pen (Flowmaster type) with ink and felts.

BRUSHES

Of all the implements used in drawing—pens, pencils, crayons, charcoal, and so on—the most versatile is the brush.

Brushes seem to be made with almost every type of hair: the tough hog hair

for oil painting; squirrel, ox-ear, camel, and sable for water color; badger and fitch hair from the skunk for varnishing; goat hair for Chinese brushes; civet for black sable, and so on. But the best of all these, and the most sought after, is the red sable which, because of its length—rarely exceeding 1½ inches—has a remarkable springiness and fineness. When properly cared for, it has a considerable life.

You can produce almost any effect with a sable brush—fine lines like a pen; tones like lead, carbon, or Conté; gray fuzzy lines like charcoal; and washes. Its possibilities are endless, and so it has been greatly favored by artists throughout history. The variety and scope of brush drawing will be discussed in its appropriate section; it is enough to say here that the brush is a most valuable piece of equipment and therefore should be included in your list (Fig. 6).

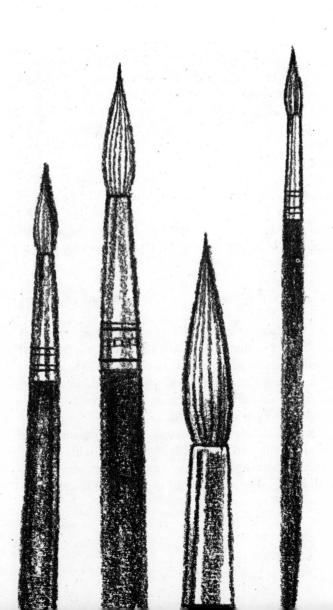

Fig. 6. Types of sable brushes.

INKS

Almost any sort of ink can be used for drawing. There are free-flowing fountain-pen inks and waterproof inks.

Fountain-pen ink is thin in consistency so that it will not clog the nib, and it is intended for writing.

Waterproof ink is thicker and more durable. It can be diluted successfully with distilled water. Waterproof ink has some property in it that makes it really "waterproof," but it is inclined to clog most pens.

These inks come in all colors and, unlike fountain-pen inks, have a varnish-like finish. Black is the most popular color and is extensively used by architects and artists who do work for reproduction.

Both varieties of ink can be combined with the other drawing mediums.

PAPERS

Most modern papers are made of wood pulp, sized and bleached, and are ready to use immediately after manufacture. But the best paper is made from rags and is hand made. It is tougher, more durable, and, naturally, more expensive. For this reason alone it is not widely used commercially.

Papers are treated for different purposes. They are coated and given a glossy finish for fine printing. They are "hot-pressed" to make them smooth and strong for printing, wrapping, and so on.

Newsprint is the cheapest type of paper. Since it is expendable, it is not treated at all; therefore it tends to get yellow in time and often pulls to pieces if it is carelessly handled.

One can draw on any kind of paper—even newsprint—but for the ease of working and durability, the most satisfactory papers are those especially manufactured for drawing.

Drawing Papers. Drawing papers are classed according to *surface, color, thickness,* and *size.*

The qualities of surface can be divided into three groups: *rough, medium,* and *smooth.* Rough papers are usually called "rough" in the trade; the medium is called "not" or "not hot-pressed"; the smooth is called "hot-pressed."

The smoother the paper, the more difficult it is to draw on because the surface has no bite. Rough papers are also difficult because they have too much bite. Therefore the medium grades are most widely used.

The medium-grade paper, also called "cartridge," is ideal for a beginner. But small quantities of the rough and smooth can be used to experiment with.

The color of paper can affect a drawing in many ways. If the color is too strong it can overwhelm the drawing. Therefore, neutral tints are usually em-

ployed by manufacturers to color papers. These tinted papers can be used to extend the range of tone or to soften it.

The *white papers* vary as well. They range from a blue white to a yellow white. This color change is often caused by the way the paper is treated, and it will be found that the smoother papers are often bluer than the rough. Bristol board, one of the smoothest, is very blue in tone. Cartridge is inclined to be yellow. Hand-made papers generally have the best balance tone of white and therefore are often used for water-color work in which any blueness or yellowness would affect the colors.

The thickness of the paper varies, depending on the manufacturer. Cheap papers are generally thin and not so durable.

Papers are usually priced by size and weight of ream.

Demy	15″×20″	25 lbs.
Medium	17″×22″	34 lbs.
Royal	19″×24″	40 to 60 lbs.
Imperial	23″×31″	70 to 300 lbs.
Double Elephant	27″×40″	240 lbs.

Cheap Paper. The advantage of using cheap paper is that it does away with any inhibitions that might be caused by expensive paper and unavoidable wastage. Cheap paper is perfectly adequate if these points are borne in mind when choosing it:

1. It must *not be too thin.* (Thin paper is easily torn or damaged and wrinkles with ink or water-color washes.)

2. It must *not be too absorbent*—like blotting paper.

3. If a white paper it must *not be too yellow* in tone. (Both absorbency and yellowing are due to poor treatment and must be avoided if you want the drawing to last.)

4. If smooth it must *not be too greasy*—as this can be unpleasant.

5. If tinted see that the dye does not taint any white chalk or Conté used on it.

A white paper that fulfills most of these conditions is cartridge. Often the only difference between the cheap and expensive types is the thickness, the cheaper being thinner. You can economize further by buying large sheets (or even a roll of paper) and then cutting to size yourself. Large sheets and rolls are always less expensive.

Tracing and Detail Papers. As their names suggest, both tracing and detail papers are very useful for tracing. The ability to see through them so that you can redraw or repeat a drawing can save an enormous amount of time and trouble.

Tracing paper has an opaque, milky look and has a slightly greasy surface. It

is rather like waxed paper used in the kitchen. This particular surface is only used for drawing with a pen and waterproof ink. Any sort of pencil tone shows up very badly.

On the other hand, detail paper will take either pen or pencil. It looks just like an ordinary, rather thin, medium-smooth paper and has the added advantage of being transparent enough to show up anything underneath. It is ideal for quick drawings and tracings. However, detail paper fares very badly with too much pressure or overworking, and if it is used for ink or water-color washes it crinkles and looks unpleasant.

The Right and Wrong Side. Most papers, and cartridge in particular, have a slight difference in surface on the two sides. This is due to the way in which they are manufactured. One side is always more absorbent than the other and is known as the *wrong* side. The other is the true surface and is known as the *right* side. *This is the best side for drawing.* Test by feeling it and holding it to the light.

Some papers, even the expensive ones, are often slightly greasy because of bleach or size used. This can be easily remedied by giving it a *gentle* sponge-over with clean water. A few drops of detergent in the water may help to remove a very greasy surface.

TO SUM UP. Buy a selection of papers, thick and thin, rough, medium, smooth, and tinted, with the bulk made of cheap, medium-surface cartridge. This should meet all contingencies. (Paper can also be bought made up in sketch-pads, but for drawing indoors, loose paper is much better.)

DRAWING BOARDS

When you are drawing in your studio or at home, drawing boards are absolutely essential. They are not so necessary for working outdoors, where comfort and speed of working is often impeded by their clumsiness. For outdoor drawing, it is far more convenient to use a notebook or sketchbook (this will be discussed further in the section on outdoor drawing).

A practical drawing board must have these points:

1. It must not be too large.
2. It must not be too heavy.
3. It must be perfectly flat.
4. The corners must be true. (You may wish to use it with a T-square and triangle later.)

To begin with, a board about 24 inches by 16 inches will be practical. Buy one made of soft wood, so that it will also be light in weight.

Treat surface of the board carefully, avoiding knife marks, pencil scores, and dents caused by dropping it. Dents and ridges, pinholes and gullies will make drawing on it unpleasant.

When fixing paper to the board, use clips or masking tape. Avoid pins, as they pepper the wood with tiny holes which eventually destroy the corners.

Avoid cutting paper and sharpening your pencils on your board. Keep it in spotless condition. Dirt on the board quickly gets onto your paper.

A drawing board should serve you a long time if treated well.

EASELS

An easel is mainly used to support canvas or a drawing board. It is absolutely necessary for oil painting or for large drawings like mural cartoons, and so easels are usually rather large and sturdily built.

For doing an average-sized drawing an easel can be an encumbrance. It is more comfortable to use a table, the back of a chair, or a donkey (Fig. 7).

The advantage of using a table is that you can keep your mediums handily beside you—pens, pencils, water pots, and so on. If you work at an easel you will require a table as well.

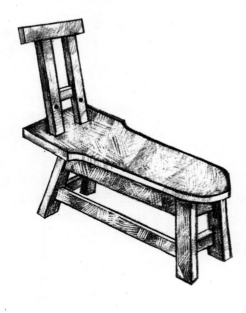

FIG. 7. Studio donkey.

FIXATIVES

Most drawings need fixing. Except for pictures executed entirely in wash or waterproof inks, most drawing mediums have a tendency to smudge. Fixa-

tives are usually made with shellac, are cheap to buy, and easy to use. When they are sprayed over the drawing, an imperceptible transparent film is put over the surface and "fixes" the drawing, protecting it from further harm.

A fixative behaves in much the same way as a varnish does. It is somewhat like a protective window.

A drawing can be fixed while it is being worked on. Redrawing over a fixed part is not affected by the fixative. It is not a bad practice to fix every stage of a drawing done in charcoal. Charcoal has a tendency to rub off very easily.

Fixative is an important and useful item. It can be sprayed on with a spray diffuser (Fig. 8) or an aerosol (the latter being less fatiguing but more expensive; see Fig. 9).

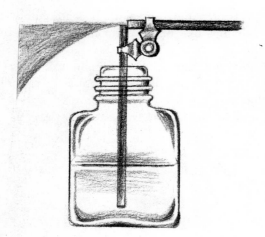

FIG. 8. Spray diffuser for fixing drawings.

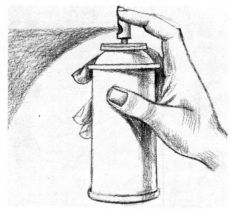

FIG. 9. Aerosol diffuser for fixing drawings.

How to Fix a Drawing. The drawing to be fixed should be placed at an angle of 45 degrees, and the fixative should be sprayed across the surface of the drawing once from about 2 to 2½ feet away (Fig. 10). It dries rapidly. Test it to see if any of the drawing rubs off. If it does, fix it again.

Avoid spraying too near to the drawing.

Don't soak the drawing.

Don't touch the drawing or draw over it until you are perfectly certain it is dry.

A drawing can be fixed and drawn over as many times as you wish.

A cheap fixative can be bought at any art store, or made at home with one part of wood shellac varnish to one part of wood alcohol. Mix well and keep tightly corked when not in use.

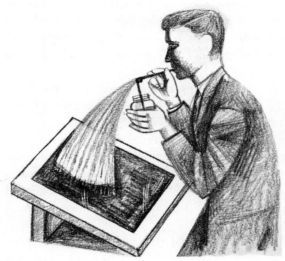

FIG. 10. Fixing a drawing
with a spray diffuser.

PORTFOLIOS

After a drawing has been fixed, it should be put away safely. Any completed drawing should be kept for a time. It helps to chart your progress clearly and you may want to show it later. A good place in which to keep drawings is a *portfolio*.

A portfolio is especially made to protect drawings and to transport them safely. It can be made or bought in various sizes. Choose one that will hold all the different types of paper you normally use. Again, it is unwise to buy a large one, since it is awkward to store and carry about.

A large cupboard with flat shelves or a filing cabinet for storing paper is also a suitable place to keep your drawings. The essential thing is to keep a drawing flat—it is irritating to show a crumpled or rolled-up drawing.

CARE OF EQUIPMENT

Care in using equipment will give you greater pleasure in using it. If you take good care of it, it will also last longer.

Drawing equipment is not as expensive as that used for oil painting or sculpture, but it is unnecessary to incur added expense by misusing it. Also, if you make an effort to care for your materials you will be training yourself to become more sensitive to them. And they, in turn, will respond more sensitively to you.

It is wrong to think that artists have no feeling for their tools. It is a romantic conception fostered by cheap novels and films that artists can create masterpieces without a thought about their implements.

Pens and brushes mature like good wine; they are not always at their peak when you first buy them. However well they are made, however expensive to buy, they will inevitably be a little stiff, a little too new. If you gently work them in they will function better and eventually will respond entirely to your touch.

It is unwise to let anyone else use your equipment. A brush that has been broken in entirely to your satisfaction can be ruined by another person's hand. This may sound ungenerous, but it makes good sense.

Sharpening Pencils and Crayons. Pencils and crayons, because they are sharpened to a point, wear away quickly, so it is well to know how to sharpen them with as little waste as possible. You will need some practice to get a good point, but with perseverance it won't take long. A good sharp point on a pencil or crayon makes all the difference.

The major difference between sharpening a pencil and a crayon is that a pencil has the wood to support the point, whereas the crayon has not. You can therefore *cut away from you with a pencil* (and with most carbon Conté pencils), but *with the crayon you should cut toward you*, away from the point (Fig. 11).

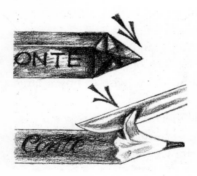

Fig. 11. Sharpening Conté crayon toward the point.

For lead and carbon pencils it is better to have a long point, not a blunt stub. But for the thicker Conté pencils or charcoal pencils, which are softer, less wood should be cut away, as it supports the softer, more crumbly centers.

It is safer to use a knife or razor blade for sharpening than to use the so-called pencil sharpeners employed mainly in offices. These give the wrong sort of point needed for drawing and break the softer mediums completely. After sharpening away the wood, you can also get a fine point by rubbing the center on fine sandpaper.

The thing to remember is to *sharpen your point repeatedly*. Points not only get worn down, but harden and respond unpleasantly to the touch. Blunted pencils also score ridges in the paper and make a drawing look unsightly.

A sharp point will always work better for you. Get into the habit of looking

after your pencils and crayons right from the beginning, then it won't be an effort later.

Setting Out Equipment for Drawing. If you learn to set out your equipment properly you will also fall into the good habit of taking care of it. The two things go hand in hand.

For instance, keep all your lead pencils in a box away from the Conté and carbon pencils. Keep your crayons in their respective containers. Crayons are brittle. They will powder easily if they are roughly treated, so it would be wise to protect them from harm by putting some cotton in their box to prevent them from falling against each other.

Brushes, when not in use, can be kept in a box, but add a moth killer. Moths can ruin a brush in no time at all.

If there is no need for you to pack your equipment away each time you use it you can leave your pencils and brushes standing in separate jars. This is much more convenient.

Whenever you begin drawing, always make a point of fixing your paper onto the board *squarely*. Don't let it flap at the edges. Secure it *firmly*. A drawing done on a piece of paper that is fixed at an angle or flops around during the course of your drawing will have a curious viewpoint. It is also irritating. Comfort is essential to the enjoyment and fulfillment of a drawing. If you are not comfortable you will become irritated. If you become irritated you cannot be enjoying yourself. If you aren't enjoying your drawing it is pointless to continue, because it will mean little to you—or to anyone else.

Water Pots and Ink Pots. If, later on, you use water for washes or for cleaning your pens, use a clean container, preferably one made of glass, and make sure it has a *wide top*. It is irritating to have to aim your brushes or pens at a jar with a narrow neck.

Inks, especially waterproof ones, should always be tightly corked when not in use. They are the easiest things to knock over, and waterproof inks evaporate if left open to the air too long.

When in use, however, keep the stoppers near their respective bottles. The wrong stopper in the wrong bottle will cause your colors to mix slightly, and colored inks don't take well to this; they tend to get muddy when overmixed.

Erasers. Erasers aren't really a vital piece of equipment. They can be dispensed with quite easily. It is better to do without them and so avoid the habit of relying on them to work miracles if a drawing goes wrong. Erasers are rarely, if ever, capable of working miracles; they are more likely to tear holes in your paper, dirty it, and ruin the surface. Keep them out of sight—for the time being, at any rate. You may find a use for them later on.

Rags. Rags are always handy to keep near you for wiping brushes, pens, and your hands, should they get messy. They are also useful for brushing off unwanted charcoal or erasing it completely.

CONCLUSION

It is unwise to try out all the equipment mentioned above in your first attempt. For a start, all you need is:

1. A drawing board.
2. A few sheets of medium cartridge paper and perhaps a few tinted sheets of different tone.
3. Carbon pencil, and white Conté crayon or white chalk.

This is the basic equipment you will need to do the exercises in this book.

CHAPTER 3

MAKING A START

Drawing is a process. It consists basically of looking and doing. Looking is accomplished with the eyes and the mind. Doing is accomplished with the hands and the materials.

DRAWING AS A PROCESS

Most of the exercises in this book will deal with the process of drawing. What must be remembered is that *this process is far more important than any end product that may ensue*. If it is remembered, more enjoyment and better results will come naturally. *Concern yourself with the process and let the ends take care of themselves.*

I shall return to this theme in different ways from time to time, until it will be seen to be true, for this is the very secret and magic of drawing and, incidentally, all the other aspects of the visual arts as well.

LOOKING AND DOING

In most cases, the experience of *looking* and *doing* will be an unfamiliar one. In the first place, many of the materials are not particularly common ones. With the exception of pens and pencils, the crayons, cartridge paper, brushes, inks, drawing boards, and so on will be new to you. To combine the use of all this unfamiliar equipment with the process of looking as well will be confusing. We must first of all clarify what goes on when we "look," and then what goes on when we use our hands. Then we must find the link between them.

As looking is far more complicated than the process of doing, the first few exercises are doing exercises—concerned with just getting familiar with your materials.

HANDS AND MATERIALS

Surprising as it may seem, we are all more adept at using our hands than at using our eyes. As I will show later, most of us are quite blind when it comes to really seeing what is in front of us. We use our hands in the ways they should be used for the ordinary things so necessary to life, like touching, lifting, pushing, tying, and so on. But even if we are not skilled in using them to do things like metalwork or woodwork, it won't take long for the hands to become practiced in handling brushes and crayons. The hands are sensitive to touch and gesture. They soon acquire the skill that is necessary to make marks, and once this happens we can safely let them get on with that part of the process while we concern ourselves with the unfamiliar process of seeing. Then the less we concern ourselves with what our hands do, the better.

MAKING MARKS ON PAPER

A drawing is made up of different sorts of marks. These are scribbled, lined, toned, washed, or brushed onto the paper. What you see determines the image these marks make on the paper. The seeing part always has some influence on what you put down, but sometimes part of what is put down influences what you see. The two are so interrelated that it is difficult to define where one starts and the other ends, but for our purposes we are going to separate them and see what makes them tick.

One of the easiest marks to make is the scribble.

The Scribble. One of the marks children make when they first get hold of a pencil or a crayon is the *scribble*. It is the most natural mark to make, and you will also find that *nearly all the marks you make have their origin in the scribble*.

FIG. 12. Some suggestions for holding a pencil: left—with the hand; right—with the fingers.

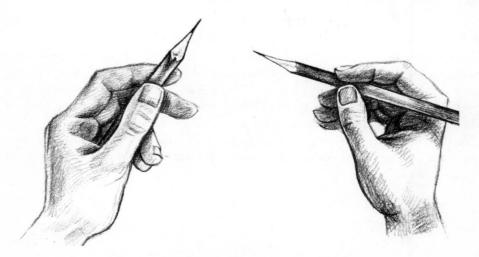

It is a good thing, therefore, to start scribbling right away—for scribbling flexes the wrist, relaxes the hand, and helps you to learn how to hold your implement in the most comfortable way. There is no right or wrong way to hold any tool, only what is most natural and comfortable for you. (See Fig. 12.) Practice scribbling and you will accomplish this.

Exercise in Scribbling. Fix some paper onto your board, firmly and squarely. Select any pencil you like (ultimately you can try them all). Seat yourself comfortably and start scribbling at the top of your paper.

Continue scribbling until you fill up your paper, either using one type of pencil or changing it for another.

Use as many sorts of scribbles as possible—long scribbles, short scribbles, broken scribbles, and so on (Fig. 13).

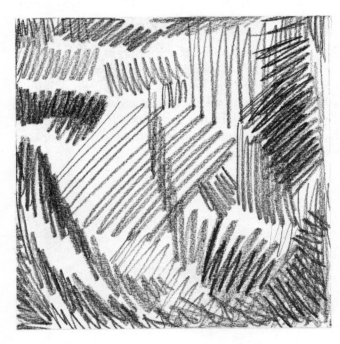

FIG. 13. Scribbling exercise.

Points to Watch. Whatever happens, keep your hand loose and your fingers relaxed. Don't grip your implement. Gripping a pencil or brush will tire your hand. The tension made by tight fingers will also make an unpleasant mark. The delightful qualities seen in a drawing by Rembrandt, or in any Chinese brush drawing, come from the ease and flow with which the artist made his statements. The beauty of a Conté drawing by Watteau is enhanced by the delicate way in which he handled the crayon. Nothing is forced; his hand was allowed to get on with the job effortlessly, naturally. In all the draw-

ings of the Italian Renaissance there is a sweep and flow in the lines and tones that come from a relaxed wrist. Scribbling will help you to acquire this. It will also help you to feel the qualities of the particular pencil or crayon you are using. You will soon acquire the sensitivity to know just what each medium can or cannot do.

So learn to scribble immediately. Cover as many sheets of paper as your patience will allow. Use the scribble as a preliminary to any drawing you are about to begin. Use it, in fact, as a way of warming up before beginning a drawing proper. Repeat the habit of scribbling at your leisure with all your mediums, and especially when trying new ones.

Scribble Into Doodling. Doodling is a way of practicing drawing without looking or thinking, and once you have begun to draw, it is a fine way of practicing. Whenever there is an odd piece of paper around—envelope, newspaper, wrapping paper—get out a pencil and start to doodle.

Scribble Into Tone. There are those who find the subtle gradations of tone —from darkest dark to lightest light—one of the miracles of drawing. Actually it is fairly easy to do if you start scribbling first. Start the action of scribbling on your paper, and without lifting your medium off the paper and by slightly varying the pressure, you will begin to get the effect of gradation. If you remember that gradation will come from scribbling and that the scribbles must be kept close together you will soon master it (Fig 14).

FIG. 14. Scribble into tone gradations.

LINE

There is a story, which unfortunately I cannot vouch for, about a child who was a rather prolific draftswoman for her age. When she was asked what she did when she drew, she said: "Why, I have a good think, then I put a line round it." To call a drawing "a think" with "a line round it" is not at all unperceptive, you will agree, for a five-year-old.

In the main, drawings are concerned with lines and with the "thinks" that go into them. Lines can express, simply and effortlessly, what it would be difficult to say in pages of words. Remember the Chinese saying "One picture is worth a thousand words," and remember that drawings done with lines only are the simplest kinds of pictures.

The drawings that speak fluently with a few lines are unfortunately the most difficult to do. In this kind of drawing the vision must be at its most profound for the drawing to picture or express it (because a drawing can do both). If an artist is a little unsure of his vision he is wiser not to attempt a "pure" line drawing too soon. It is liable to look empty. Instead of telling a lot with very little, it will tell nothing at all.

A drawing in line alone, and a few lines at that, represents the summit of draftsmanship. A good example is Hokusai. Born in Japan in 1760, he died, aged eighty-nine, saying, "Oh, if I could only be granted another five years of life, then I feel I could really draw." He had been drawing all his life. He was a really great artist. Yet he still wanted to go on trying! (Fig. 15.)

FIG. 15. Line drawing by Hokusai.

A line drawing expresses, among other things, the essence of the visual world and demands great insight. But this need not deter us from either studying or using line. For though it will be easier to show with tones at the beginning, we shall also be concerned with some sort of line. Lines come to a draw-

ing whether we want them to or not. We have to use them. So let us see what
sort of lines we can produce.

Exercises in Lines. Using any of your mediums (as with the scribble), draw
some lines on a clean piece of paper.
 Draw lightly.
 Draw heavily.
 Draw long lines, short lines, horizontal lines, vertical lines.
 Draw a scribble line.
 Draw so that the line varies in thickness.
 Draw so that the line varies in density (lightness and darkness).
 Draw some flowing lines.
 Draw some staccato lines.
 You will observe the amazing flexibility of a line and the surprising things
you can do with a simple line.

Lines Into Shape. A line can do two things at once: It can define the *in-
side shape* and it can define the *outside space*.
 Line into shape is too interrelated with visual shape proper to go into here,
but when we discuss visual shape some exercises in line and shape will be in-
cluded. For the moment, the above exercise will be sufficient to introduce
the uses of line.

TONE

 Line and tone. How often you will hear those two qualities mentioned in
relation to drawing. For it is with these two powerful ingredients that drawings
come about. They are the simplest effects to obtain.
 Tone is so related to what we see that it is difficult at this juncture to do jus-
tice to it. So, before we go into it in detail, we should discuss the other side of the
activity of drawing, namely, looking.

THE PROCESS OF LOOKING

 We use our eyes differently for drawing than we do for everyday purposes.
Our observations and reactions to what we see in daily life are briefer and less
intense than they will need to be for drawing. We have developed our sense of
sight for purely practical ends. It is an adjunct to the business of living. We use
it to recognize, judge, and avoid, but not to contemplate. We make our eyes do
these things quickly, so that we can act quickly. Half the time we are not really
looking around us at all.

Most of the time we see by memory.

We are merely reading labels in our heads that the physical sensation of sight conjures up.

You see a face; it possesses eyes, nose, mouth, chin, and hair, and if the sensation stimulates your memory, you say: Well, well, it's Uncle Bob! You are not concerned with looking at that head from the point of view of its form or tone, or how it looks against the light. You are merely using it to refer to your well-stocked memory of faces to *see whether or not it coincides*. If it does coincide it is Uncle Bob and you are satisfied. Your eyes have done all they needed to do at that moment. If the features don't accord with your memory you don't bother to look any further. It would be, from a practical point of view, a waste of time.

We do this with more or less everything we see around us. Landscapes, the town we live in, the people who walk around it, the way they move—we see all these things not as a visual experience, but as something culled up from our memory.

When we come up against something new, something we cannot refer to in our memory, the experience will be a disturbing one. Memory gives us a sense of security. Unfortunately, as far as drawing is concerned, it is a false one.

Time to Stare

With drawing, we certainly see, sum up, and act, but there is this difference: *We have no need to act quickly*. Seeing something, perhaps for the first time, without the need to act quickly—without having to do anything other than make a few marks on paper—is a completely new state of affairs. The whole process is slowed down. Consequently, we have no need of labels or memory.

However, the shock of looking without labels can be disturbing. You begin to doubt your ability to see at all. When you have become so used to recognizing everything by labels, it is hard to break the habit suddenly. When the labels are removed, the world looks a bit naked.

But again, there are some consolations. When we were children, our label-memory filing system had not reached that of adults, so that as children we were not put off by looking without them. That is one of the reasons why children are so uninhibited about drawing. They accept what they see without question.

We see this world without labels brought to a higher degree in the works of more mature artists, and we wonder at them. They "open up our eyes," we say. They show us a world that is more interesting, more exciting, and full of wonders we never imagined.

THE COMMON DENOMINATOR

Once we have discarded memory-label looking, what have we left to fall back on? There must be something that unifies all the activity of looking, so that we, as artists, can do something about it. There must be something that we can grasp with our minds that is not too difficult to understand, but is a key to "non-label" looking. There is.

There is *one* quality that all *physical* things possess, regardless of their label (name) or function. There is *one* factor that is inherent throughout the visual world. You see it in everything you look at. Whenever we draw, it is the one thing we draw over and over again. We use this factor whenever we draw, paint, sculpt, or design. What is this vital factor? The answer is shape.

There is shape in everything we see. It is shape we draw when we draw. It has no fixed label. *Shape does not only apply to solids. Shape also applies to spaces.*

You know that most solid objects—boxes, jugs, chairs, tables, buildings, trees—have a clearly defined shape, but have you ever thought that the spaces around and between these objects have a shape as well? Because, though more subtle, more complicated, therefore at first glance more confused, *space has shape too*.

Most of the examples shown and most of the exercises given will deal with the problems of sorting out the shapes as solids, and the shapes as spaces.

The next step to consider is how to define those shapes on paper. Well, as suggested earlier, one way is by *line,* and the other way is by *tone,* or by a *combination of line and tone.*

LINE AND TONE

Tone is the degree of lightness or darkness of any given shape. (Tone can also define in monochrome the relative color of objects; that is, the difference between yellow and green, for example, is shown by the lighter tone given the former.) Tone can deal with light and the absence of light on any object or space. You can also use tone to define the play of light when it is diffused or shifting.

The use of line for drawing is quite different. For one thing, *we do not see things by line*. Line is a convention used for drawing. We see things by *color* and *tone*. Therefore, it is much simpler to make a more convincing image on paper by tone than by line.

Lines are more precise. They are a calligraphic shorthand for dealing with what is visually complex. They make statements that are brief and to the point. They are, to a certain extent, a limitation on what the artist sees. It is difficult, for instance, to render with lines the subtle shades of light that fall on shapes. It

is practically impossible to show the complex changes of plane by line alone. The solid, three-dimensional world about us is depicted more convincingly with tone.

It is natural to want to draw solely in line, but it is difficult for a beginner to create a convincing image in the initial stages. Therefore, for the time being, lines must be used with tone. By combining them, you will learn more about both.

Exercises in Line and Tone. These exercises are concerned with defining simple shapes, first by line and then by the addition of tones.

EXERCISE I. SHAPE

1. On a clean sheet of paper, draw, in line, with any one of your mediums: a circle, a rectangle, a triangle with base down, a triangle with base up, and an oval. Draw them, if possible, *without corrections*. This is important. If the habit of drawing is begun without fumbling, a better understanding will develop of the uses of line. You will grow more confident, and drawing in line demands great confidence. You can fumble more with tone. Corrections are easier here.

2. Underneath, draw a series of shapes combining the circle, the rectangle, the triangles, and the oval (Fig. 16).

3. Now fill in each shape with tone, *correcting* the shape as you go to suit

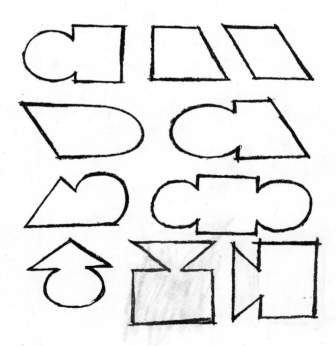

FIG. 16. Combinations of a circle, rectangle, triangles, and ovals in line.

yourself, starting with a light tone and proceeding by degrees to black, then reversing the process until you are back to gray again (Fig. 17).

Here you have defined all the *solid* shapes, by line and tone; the spaces around them are left white.

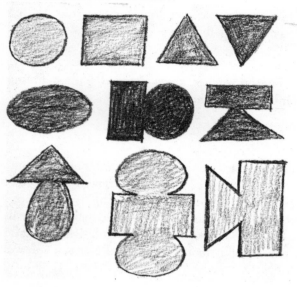

FIG. 17. Toning geometric combinations from gray to black.

EXERCISE 2. SPACE AS SHAPE

1. Repeat, as above, drawing all the shapes in line. (You can vary the combinations if you wish.)

2. Instead of filling them in, this time fill the spaces around them with a medium-gray tone, or if preferred, a changing gray to black tone, or even a solid black one (Fig. 18).

Now you have drawn the space as shape. The spaces this time have defined the solids, using line and tone.

FIG. 18. Toned background of geometric combinations.

CHAPTER 4

BEGINNING TO DRAW –
THE STILL LIFE

The Simple Still Life

The still-life group is usually made up of a few inanimate objects, either put together by design or discovered in a corner of a room. It usually consists of jugs, bottles, pots, pans, flowers, fruits, vegetables, fabric, and so on—in fact, anything that is around the house. It is one of the simplest subjects. Nearly every artist at some time has used still-life subjects. They are exciting to draw (or paint) and are also ideal for studying shape, tone, light, and so on, under perfect conditions. A still life never moves by itself. It can be pushed around just as you wish.

Later you can probably discover all sorts of naturally arranged still-life subjects in your home, but for the moment we will arrange a still life for you.

For this exercise you will need three simple objects—a jug, a bottle, and a pan—and some simple, medium-toned cloth as a background. The objects chosen should be, if possible, white, gray, and black in tone (the color is immaterial—it is the *tone* that counts).

Lay the material chosen for the background behind and underneath the group. Arrange the objects simply on the cloth. Make sure that each object is clearly seen

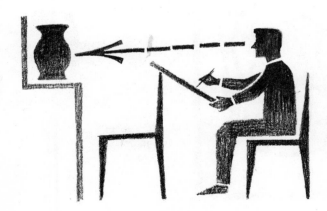

Fig. 19. The correct way to sit.

as a *shape* against its background. For this reason, illuminate the group so that there are as few shadows as possible. For this exercise they aren't important.

This is the first exercise in drawing with something in front of you, so it is essential to make yourself comfortable and sit correctly facing the group (Fig. 19). If you are badly placed in front of your still life you will not be able to do yourself or it justice.

1. Draw the group in a simple line, just as you see it, but *draw the shapes only* (as in the previous exercise). Ignore any shadows you may see. Just bear them in mind (Fig. 20).

2. Fill in the background with the medium tone (Fig. 21).

3. Now fill in each object with its respective tone, leaving the white object untouched (Fig. 22).

This exercise touches upon four points:

a) The problem of arranging a group.

b) Becoming aware of tone and *the relationship of tones.*

c) Seeing the shapes as tone and relating those shapes.

d) Limiting the problem to just these things.

You will, of course, be aware that there is a lot more going on than just those few things. But being limited, you will do best to proceed step by step and avoid being confused—so that when the next problem comes, you are ready for it and it is easily solved.

Therefore, never try to do too much. Take the simple approach, however inadequate it may seem at the time.

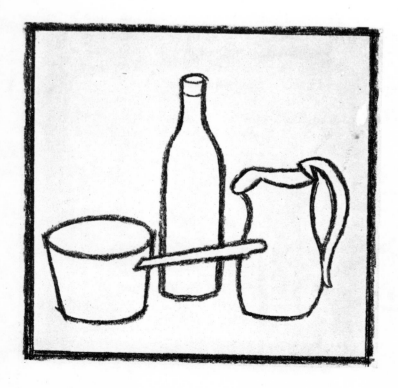

FIG. 20. The still-life group in line.

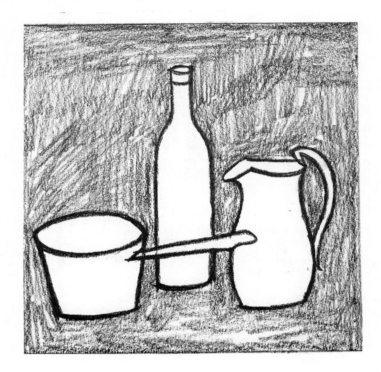

FIG. 21. The still-life group with background filled in with tone.

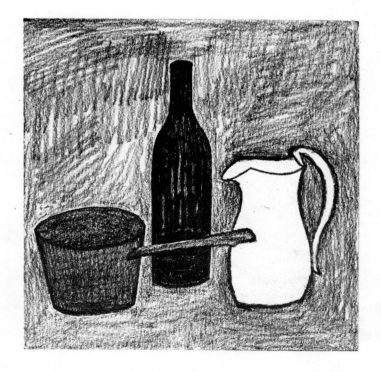

FIG. 22. The still-life group with each object filled in with respective tone.

The Complicated Still Life

All visual reality is basically made up of shapes—solid or spacial—and each shape has a different character. Some shapes, because of their simplicity, are easily seen. Geometric shapes, like rectangles, cubes, triangles, pyramids, circles, and spheres, are instantly recognized and are easily dealt with in drawing. We can all draw these geometric figures roughly. But though we can manage all of these with a certain amount of conviction, the rectangles and triangles are easiest. It is a little more difficult to manage a cube, a pyramid, or a sphere with equal success.

Why?

For one thing, the rectangle, triangle, and circle are all on *one plane*. A cube, a pyramid, and a sphere have more planes. It is this that makes them solid, or three-dimensional.

Planes

Every solid object is made up of planes. It is the way in which these planes form the surfaces of an object that is of most interest to us. These planes are affected by the *light* and by *the viewpoint from which they are seen.*

In a simple object like a cube the planes can be easily seen and defined by line. If you are slightly above the cube the planes that you see are the top and the two sides. Seen dead on in front, the cube is just a square; from any other position, the sides of that square change their *angles.* We must concern ourselves with these angles: how they vary and to what extent, when we start to look (Fig. 23).

However, in a round object the angles are not so readily defined. Nor are the planes, and it is impossible to render them by line.

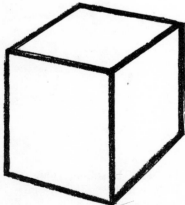

FIG. 23. Planes: a cube in line.

FIG. 24. Planes: a sphere in line.

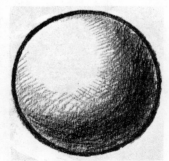

FIG. 25. Planes: a sphere in tone.

The changes of plane that take place on a cube are abrupt; the *changes on a sphere are gradual*. If a line is used to show that change it will not help to make the sphere look round; on the contrary, it will flatten it (Fig. 24).

Therefore, we are compelled to use tone because we can *gradate* tone. Tone can be employed successfully to indicate how those softer changes take place as the object curves away from us. But at the same time, we will be much more dependent on the light that falls on those planes to achieve this suggestion of roundness (Fig. 25).

LIGHT ON PLANES

Since most objects are not solely cubic or spherical, but a bit of both, *light* will play an important part on how the planes will be revealed to us. We see everything by light; it is the basis of sight. Even though a cubic form can be rendered quite well by line alone, it becomes much more convincing when the light that falls on it is put in as well. *The light reinforces the change of plane and so adds to the structure.*

For the moment, it will be this one important quality that light possesses—that of intensifying the planes—that will concern us most. Light can, of course, do a great deal more, but for the time being we can eliminate its more complicated aspects and concern ourselves with six simple things regarding light and the effect it has on spherical objects.

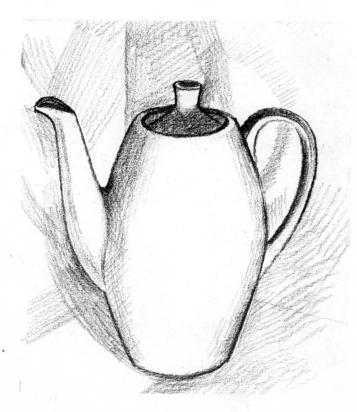

FIG. 26. Light from the front: flat.

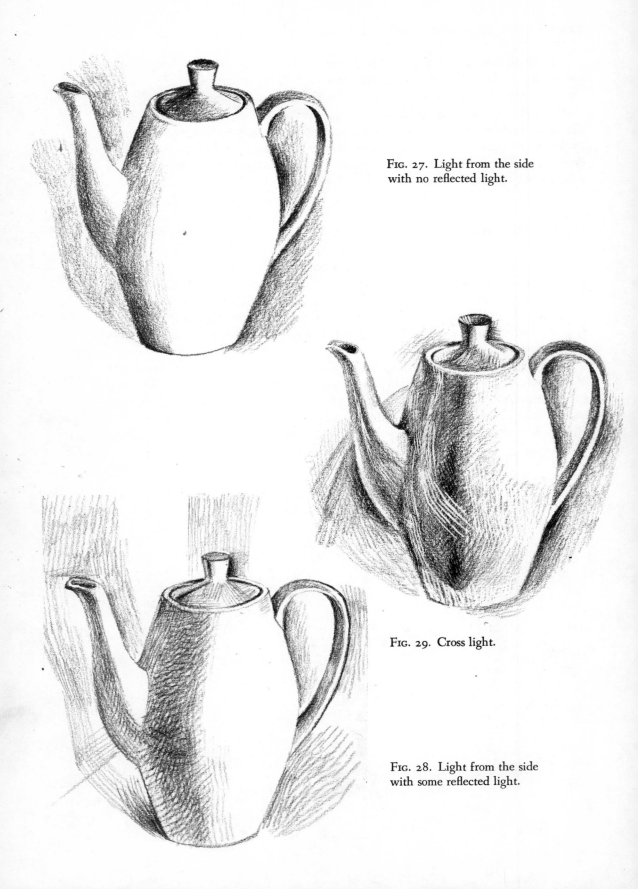

FIG. 27. Light from the side with no reflected light.

FIG. 29. Cross light.

FIG. 28. Light from the side with some reflected light.

1. FROM THE FRONT—A light directed at the front of a spherical object will flatten it and will reduce its three-dimensional quality (Fig. 26).

2. FROM THE SIDE—Light from the side will accentuate the change of plane. With a side light, the plane nearest to the light will be clear and bright, and the planes that turn away from it will be dark, but clearly defined. However, toward the edge of the object the planes come to an abrupt end and do not have that suggestion of continuing curvature (Fig. 27) that reflected light gives to a spherical object.

3. REFLECTED LIGHT—If we throw some extra light on the planes that are in shadow and which are looking a bit flat, then those planes that are turning away from us will be revealed as well. Fortunately, light has a tendency to "bounce" off surrounding objects or background, if these are not too dark in tone. This "bounced" light is usually referred to as the reflected light, and if you look for it you will invariably find it. A great advantage of using reflected light is that it tends to make the edges of a rounded object "go around the corner" (Fig. 28).

4. THE CROSS LIGHT—If, on the other hand, the reflected light is too dim to be of any use you can deliberately light up the shadows with an extra, but weaker, source of light. This is usually known as a cross light, well beloved by photographers, who use as many as five or six of them to lighten the shadows. However, if used to excess, a cross light so distorts the planes that confusion—not clarity—is likely to be the result (Fig. 29).

One of the best ways of lighting up the shadows is to reflect light from the main source with a piece of white card or material.

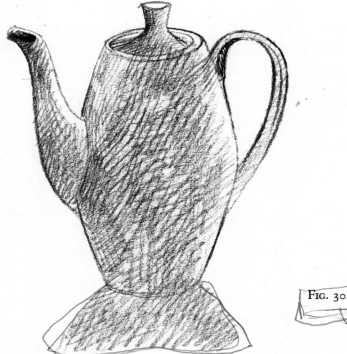

FIG. 30. Silhouette.

With a bit of ingenuity you can arrange to have a piece of white card or material near the object to throw up just enough reflected light not to look obvious or contrived.

5. THE SILHOUETTE—When the source of light is behind the object (as when it is in front), it tends to flatten. The object, in this case, is dark (Fig. 30).

6. BACKGROUND—Usually the background is affected more by the objects in front of it than by the light source. The brightest planes on the object tend to make the background look dark, and behind the shadowed part of the object the background often looks lighter (Fig. 31).

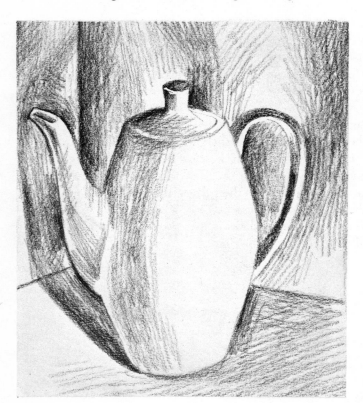

FIG. 31. Background affected by the object.

DAYLIGHT

You will see that when arranging a still life under artificial conditions, you have some control over the source of light. Most of the above factors will then be seen to be true, but under natural lighting conditions (daylight) there are some complications:

a) Daylight, though more pleasant to work in and to look at, is not so flexible as artificial light and not so constant.

b) Daylight is always on the move and can change all too suddenly for comfort.

Hence the importance of setting up all your still-life subjects under artificial conditions until you have satisfied yourself that you have understood the simple things light does. Later it will be easier to continue under natural conditions (Fig. 32).

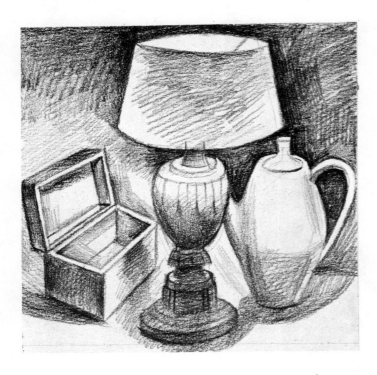

FIG. 32. Still-life group showing full use of available light.

EDGES AND CONTOURS

As a plane disappears from view on a round form, the edges sometimes melt into the background. They are softened because, unlike planes on a cubic form, the plane on a sphere (or a rounded form) continues beyond what we can see. In a cubic form the plane comes to an abrupt ending. The edge is hard and clearly defined (Fig. 33).

It is this softening, or melting of the edges, on a rounded form that gives just this impression of continuing "around" behind what we can see. This effect is created by light, and so in a drawing, naturally, the effect is achieved by tone. In a drawing done in line alone, this gentle change of moving around the corner—in which tone plays such a vital part—can only be achieved by varying the quality of the line (Fig. 34).

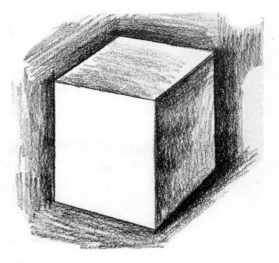

FIG. 33. The hard edges of
a cubic form.

FIG. 34. Line drawing by De
Segonzac showing variations
needed to express form.

The study of what happens to the contour—or the edge of the object—is of
utmost importance, whether you draw in line or in tone. Naturally, it will be
easier to achieve the sense of contour if you use tone. You are aided by the fact
that a tonal edge comes nearer to what you actually see. There are no lines in
nature like those you make in a line drawing. A line drawing is a way of

putting down the essentials of what we see. So, until we really understand the nature of the contour and what happens to edges under different lighting conditions, it is advisable to employ as rich a tonal range as possible and not rely on line alone. (See Fig. 35.)

FIG. 35. Conté drawing by Jean Antoine Watteau (French, 1684–1721).

The points to remember are:

1. A line drawing is dependent on contour or edge.

2. A total drawing—one with line and tone—is an easier way of dealing with these things.

3. To draw convincingly in line, a thorough understanding of an edge or contour is needed.

4. For the time being, therefore, it is better to limit the amount of pure line used.

EXERCISE IN A MORE COMPLICATED STILL LIFE

In this exercise, the emphasis will be on *light* and how it behaves.

1. Choose three simple objects, as before, possessing three different grades of tone: white, gray, and dark gray or black; only this time select those objects

that have combined cubic and round forms as well. If this is not possible choose round and cubic forms that are separate (boxes, books, cases, for the cubic forms; bowls, pans, cans, bottles, for the round).

2. Arrange them clearly on a medium-toned piece of cloth as before.

3. Set your light so that it is slightly above the group, but is also definitely to one side. Check to see if there are any helpful reflected lights. If not, try to arrange that there are by using a white card or an extra source of weaker light at the other side of the group.

Try not to have too many shadows thrown by the objects onto the background or each other.

4. First, block in the main shapes. Then, fill in the degree of tone that is on each object. If it is possible make a point of working on the background at the same time you work on the objects. That is, do a little work on the object, then do something to the background especially around the *contours of the objects,* then work on the object again. If you alternate in this way you will learn to relate the object to its background, so that it "sits" properly in the space.

5. Observe how the *ground plane*—what the objects are standing on— differs from the background plane, especially in terms of the light (Fig. 36).

For this exercise, use any medium you like. Go through it from start to finish without trying to correct too much, and *do not leave the drawing incomplete.*

This is most important. Get into the habit, right away, of always seeing an exercise through. You must finish what you set out to do. This will create the right mental climate for any sort of achievement. *It does not matter if the result turns out to be a mess.* It often is, on your first attempt. Persevere. Trust your reawakening ability to draw.

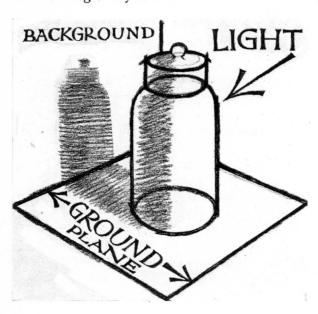

FIG. 36. The ground plane.

Points Arising Out of Drawing a Still Life

There are a number of things that must be considered when drawing. Some of them are simple common-sense things, others are a little more complicated and will only be resolved with practice. It is well to be familiar with them all, because you will come up against them time and time again. But whatever you do about them, don't let them worry or confuse you. You will eventually absorb them quite easily, once you know something about them. For instance:

POINT I. THE RIGHT WAY AND THE WRONG WAY TO SIT. The right way is to be *comfortable*. If you are comfortable you will do justice to your drawing. You will enjoy doing it more. Rest your board on a table, the back of a chair, or a donkey; or stand at an easel (Fig. 37).

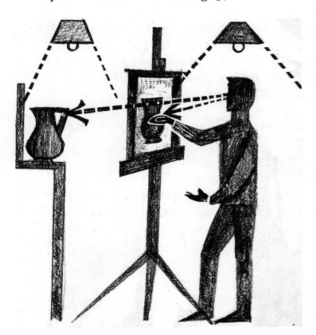

FIG. 37. Standing at an easel.

The *wrong way* is to rest your board on your knee so that it becomes numb with the weight and you cannot concentrate on what you are doing.

The right way is to *face what you are drawing* (Fig. 19).

The *wrong way* is to have to look by twisting your body or your neck, or having to strain your eyes by looking out of the corners.

The right way is to *pay attention to the light*. There should be enough to illuminate the group and your paper. Make sure that it does not glare. A strong light that shines directly into your eyes can strain them and make you very uncomfortable.

Have all your *tools arranged neatly* by your side so that you do not have to get up constantly to find them, for this can also spoil your concentration. Always have a sharp knife or razor blade handy so that you can keep your pencils and crayons sharpened.

POINT 2. ARRANGING AND SELECTING OBJECTS. Choose objects that are simple in shape, different in color, and varied in texture (rough, smooth, patterned, clear). Avoid fussy or complicated shapes. Arrange them simply at first (Fig. 38), then as you become more confident, throw them together more haphazardly (Fig. 39). The aim is to create an interesting series of shapes and contrasting colors and textures. Objects may be grouped together, or, for variety, one object may be separated from the others (Fig. 40). You can even try turning them on their sides or upside down (Fig. 41).

Fruit or vegetables may be cut in two (Fig. 42). Flowers may be strewn about. Surfaces play a large part in creating interest, and you can vary these and the background as well.

The sort of lighting you choose will also change and alter your groups. Keep it simple until you can manage more intricate cross lighting. It is amazing how many variations you can achieve with three or four simple articles.

POINT 3. CONSTRUCTING THE DRAWING. You may start at the top of your paper (Fig. 43).

You may start at the side of your paper (Fig. 44).

Or you may prefer to begin in the center (Fig. 45).

No matter which way you choose—and it is a good idea to try each way eventually—keep your drawing simple at the beginning and use as few lines as possible.

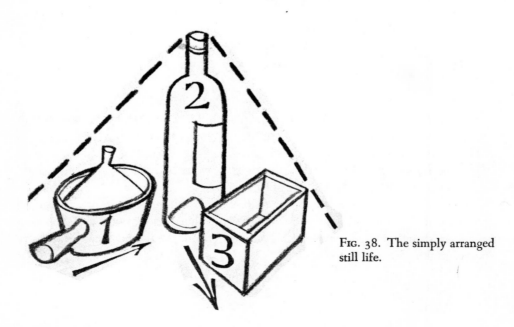

FIG. 38. The simply arranged still life.

FIG. 39. The "as found" ar-
rangement.

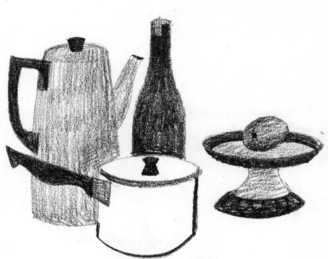

FIG. 40. Still-life arrangement
with one object apart.

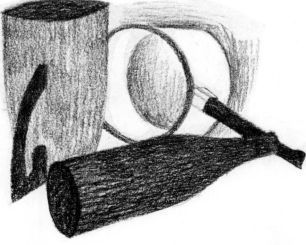

FIG. 41. Still-life arrangement
with objects upside down and
on their sides.

Fig. 42. Drawing of cut fruit.

Fig. 43. Beginning a drawing at the top.

FIG. 44. Beginning a drawing at the side.

FIG. 45. Beginning a drawing in the center.

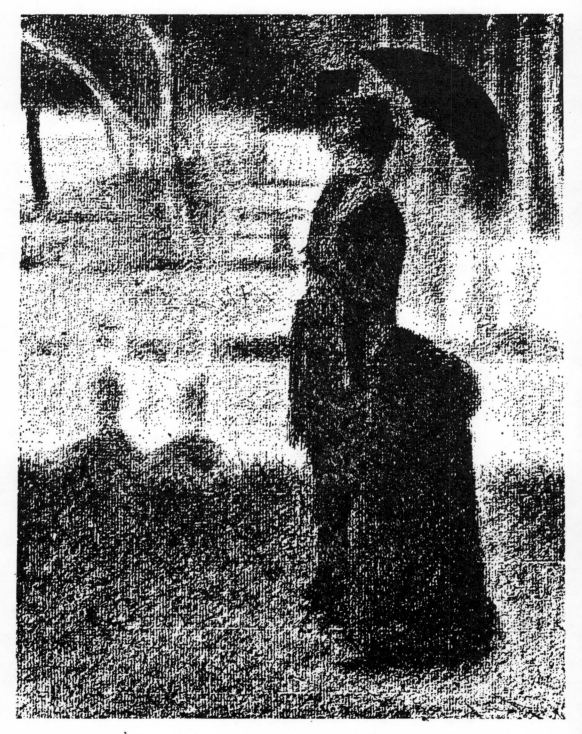

FIG. 46. Finishing a drawing simply. Study for "The Big Park" after a drawing by Seurat.

Don't worry if the drawing seems to get confused. Let the shapes grow. Don't put too much stress on *accuracy*. If it looks wrong, leave it. Try to correct with tone as you proceed.

A drawing invariably looks wrong at the beginning. Give it time and it will eventually grow more convincing. This is so because at first you do not "see" what is in front of you with any clarity. The first few lines are always tentative. They may look wrong. As you proceed, you see more. Your eye and hand become more confident and it is then that the hand attempts to correct what you did at first.

Beginning a drawing is always a fresh experience. You can never be sure how it is going to turn out. Don't force the issue. The more you strain, the more the drawing will go awry. Therefore, avoid excessive rubbing out. It makes a mess of the drawing and is discouraging.

POINT 4. FINISHING THE DRAWING. A drawing is finished when you think you have done enough to it. This will be conditioned by the amount of time you have at your disposal and by what you set out to do. If you intend to do a highly finished drawing be patient. You cannot rush to complete a complicated drawing. Give yourself plenty of time to do justice to it. If you haven't the time try something simpler that you *can* finish (Fig. 46).

It is unnecessary to elaborate a drawing if you feel you have said all you had to say.

POINT 5. THE LIMITS OF YOUR PAPER. Whether or not your drawing is finished very often depends on how completely you have filled your paper. If you

FIG. 47. Discovering the angles in a still life made by the rectangle of the paper.

make a practice of filling your paper completely to the edges you will find that you will be helped in a number of ways.

The four edges of your paper are a standard measure that you can always rely on. Because they are fixed and unvarying, you will be able to judge the angles and shapes of objects by them (Fig. 47). Objects are varied; by relating them to the edges you will see them more clearly (Fig. 48).

Completing the drawing to the edges of the paper will also enable you to

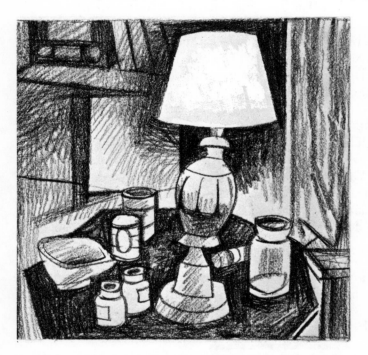

FIG. 48. Drawing completed to the edges of the paper.

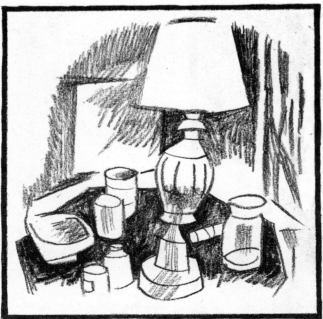

FIG. 49. Vignetting.

judge whether you have finished or not. If you leave a halo of white around the drawing it will be difficult to tell (Fig. 49).

Using the edges will make you rectangle conscious. This will not only help you to plot your drawing better, but will develop your sense of design and composition. Your arrangement of shapes will be more successfully related to the rectangle (Fig. 50).

For this reason, it is a good idea to cut a rectangular hole in a piece of card

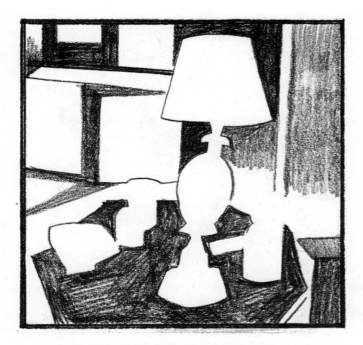

FIG. 50. How to relate the drawing to the edges of the paper.

FIG. 51. Viewfinder.

and look through it when you have set up a group. This will help you to under-
stand the limits of your paper and to choose what part of the group will best fit
the rectangle of your paper (Fig. 51).

By becoming aware of the rectangle you will learn to use what you can see,
instead of taking your subject just as it is and finding that it is unmanageable.
You will learn to choose the best position to make the subject fit your paper,
cutting out what is unnecessary and leaving in what is.

POINT 6. ANGLES. The dictionary defines an angle as:

a) a corner, a point where two lines meet.

b) geometrically, the *inclination* of two straight lines which meet but are
not the same straight line. And angular as:

c) stiff in manner: the opposite of easy or graceful (as in a curved
form).

You might wonder what possible bearing these definitions have on drawing. In
actual fact, they are of immense help and value. Let us examine each definition
in turn to see in what way.

a) The corner angle can be a right angle, an obtuse angle, or an acute
angle (Fig. 52).

If, when drawing a cubic form (boxes, buildings, etc.), you pay attention to
finding out just what kind of angles it has and assess them either as right, acute,
or obtuse by holding up and measuring with a pencil, you will be getting them
more accurately than by guessing (Fig. 53). If it is possible to compare these
angles with a horizontal or vertical line your task will be easier still. This is one
way the ready-made horizontal and vertical line on the edges of your paper prove
a great help (Fig. 54).

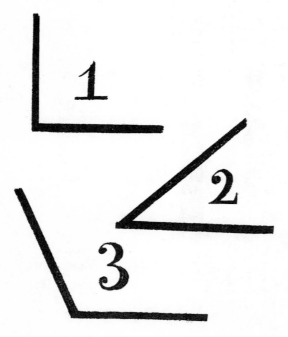

FIG. 52. The three angles:
1—right; 2—acute; 3—obtuse.

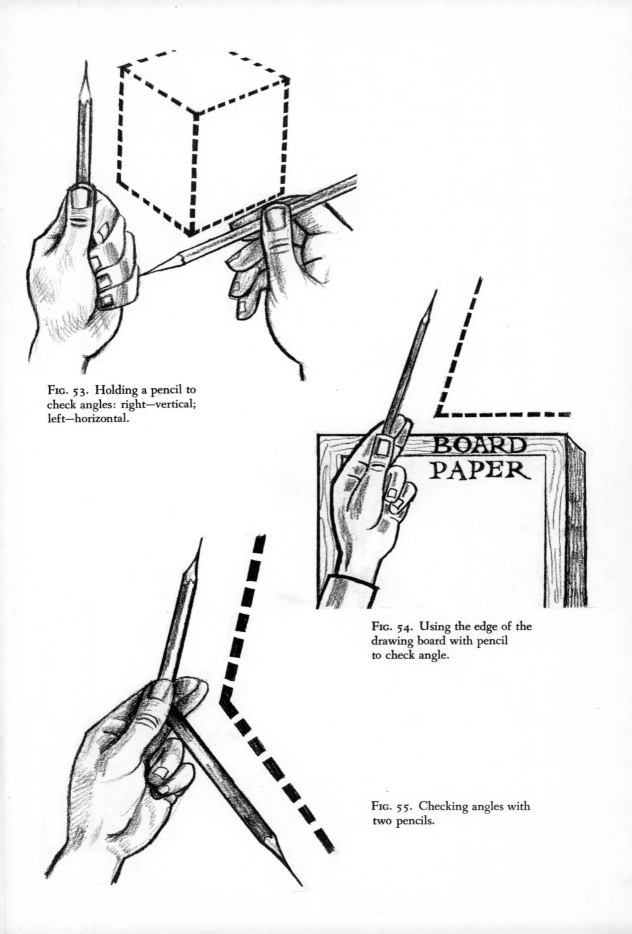

FIG. 53. Holding a pencil to check angles: right—vertical; left—horizontal.

FIG. 54. Using the edge of the drawing board with pencil to check angle.

FIG. 55. Checking angles with two pencils.

b) For an angle of type, that is, where two lines meet and are inclined to each other without really forming a corner, it should be possible to assess which way the angle moves by the use of two pencils (Fig. 55).

c) Definition of angular: stiff in manner—the opposite of easy or graceful; this seems the most unlikely way to plot anything. How can this help you to draw the very opposite, namely, rounded forms, curved forms, and so on?

Well, with this type of form (and the human figure in particular) we have very little with which to compare the curves. In the simple angles described above we can use the edges of our paper or one or two pencils. But with the subtly curved shapes of the human frame this is not so readily possible. What is there to help us?

Form Angles First. If instead of trying to plot the curves by eye alone—which is tricky—you turn them into a series of simple angles (Fig. 56), you will find that it is then a simple matter to curve them (Fig. 57) and be assured of a reasonably convincing shape.

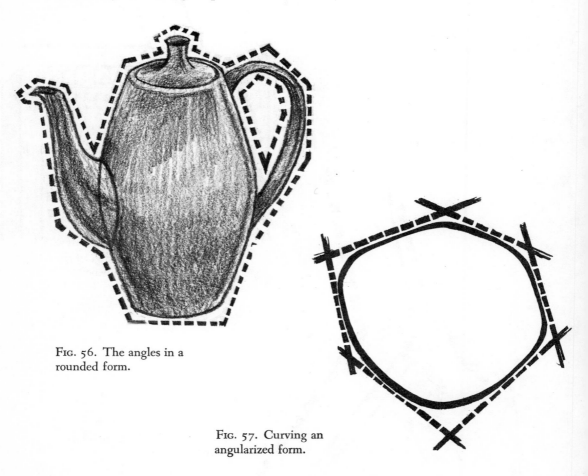

FIG. 56. The angles in a
rounded form.

FIG. 57. Curving an
angularized form.

With a more complicated form, you can use more angles. In fact, the more angles you use, the better. It is very helpful in evaluating the subtleties. It is worth the extra trouble taken. However, it may take you a bit of time to get used to seeing curves as angles, especially when your drawing begins to look like a "cubist" drawing (Fig. 58). But the more you familiarize yourself with this way of seeing curved forms, the better you will be able to draw them. (See Fig. 59.) Until the time arrives when you can do it spontaneously, pay great attention to forming angles. Not only will your work be more accurate, but your drawing, however curved and graceful, will also have plenty of structure.

This is, in truth, just what the cubists did. In an endeavor to look at reality with a greater intensity, they were forced to turn what they saw inside out. In doing so, they brought back into their pictures all the structural strength that the Impressionists had lost by being too preoccupied with light. The artists of the cubist movement (of which the Spanish artist Pablo Picasso and the Frenchman Georges Braque were the originators) reduced all the easy, graceful forms and the limpid, diffused light used by their Impressionist predecessors into tight,

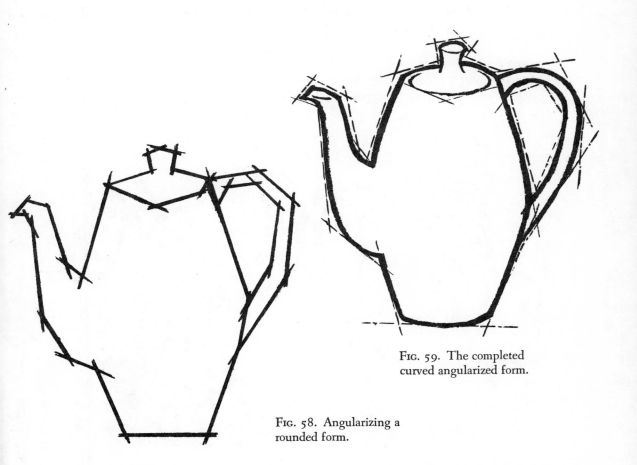

FIG. 59. The completed curved angularized form.

FIG. 58. Angularizing a rounded form.

rigid angularizations (Fig. 60)—hence, the name "cubists." By doing this, they not only gave strength and greater spatial depth to their pictures, but they revolutionized painting as well!

The images they created were ugly to the average spectator, but the loss of beautiful surface forms was to bring a clear and new type of design and composition back into painting. This development, in its turn, revolutionized architecture, book design, poster and magazine design, furniture, and fabrics. The influence of the cubists can now be seen everywhere. The ugliness of the early cubists has been softened and made more elegant. Cubism has, in its modified form, been completely incorporated into the twentieth century. If it were not for these two painters who first turned reality inside out to get at visual truth our ideas of modernity might be quite different!

Therefore, we can learn a great deal from studying the cubists. We can learn to give strength to our drawings. We don't have to follow, admire or emulate them, but we can use their discoveries. The cubists, in their turn, used the discoveries of the nineteenth-century painter Paul Cezanne. Among other things, he was also trying to put the geometry back into impressionism.

The cubists Braque and Picasso also turned to primitive African sculpture for inspiration. The elements of angularized forms can be found in the work of both Cezanne and the African carvers (Fig. 62a, 62b). Cezanne was obsessed by the *structure* of landscape, and the "architecture" of his paintings and drawings became more important to him than anything else.

"I am a primitive in the way I have discovered," Cezanne was supposed to

Fig. 60. Angularized drawing looking "cubist."

Fig. 61. Angularized head after a drawing by Picasso.

Fig. 62a. African carving from the British Museum.

Fig. 62b. African carving from the British Museum showing angularization of form.

have said. And in a way he was as primitive as the African carver who, in the most direct way, was trying to bring sculptural dignity to stone and wood, and who, because his approach *was* simple, used angular shapes to achieve it. It was, as it turned out, just these simple, angular shapes that gave Braque and Picasso the idea that if they, too, wanted to find something fresh in the visual world, they would have to take a similar step.

So cubism was born, and art took another step in its development. Looking back at this historic occasion (circa 1907), it all seems so simple and obvious.

In fact, most things seem complicated until you look into them and then they

appear simple. The complications come from within ourselves. The wisest course is always the simplest, whether it is the use of angles or their natural extension—proportion.

POINT 7. PROPORTION. "There is no beauty that hath not some strangeness of proportion" wrote the Elizabethan essayist Francis Bacon. Proportion, when it is at its most strange, certainly has an effect on the spectator—witness the distortions that occur from time to time in fashion, for visual effect! Why is proportion of the utmost importance in drawing as well? Why does it concern us so deeply that it often provokes the lament: "Oh, I haven't got the proportions right! How on earth can I find them?" On the other hand, though proportion is a mystery to some, to others it doesn't seem to matter at all.

Yet everybody has a visual sense of proportion. It is innate, like all things to do with drawing. All we have to do is to recognize exactly what it is, and understanding will come quite naturally.

Proportion can be summed up as: *how much to how little.*

FIG. 63. Breaking up the large shape simply.

Proportion deals with size and the relationship between sizes:
 a) big to little.
 b) thick to thin.
 c) rough to smooth.
 d) round to square.

Proportion also deals with the relationship of smaller parts to the larger whole.

Generally, we have little difficulty in judging the relative sizes of simple shapes when they are side by side. The difficulty is to distinguish the smaller parts of a complicated shape without being confused (as in the human figure, for example). A complicated shape like the human figure is the sum of its smallest parts. It is *by breaking down the large shape into these smaller parts* and recognizing them, that we can deal with the shape as a whole.

Angularizing can be of immense help here.

First, you can angularize the complete shape very simply (Fig. 63).

Second, break up this shape with smaller ones (Fig. 64). The angularization

FIG. 64. Breaking up the large shape more complicatedly— across the form.

FIG. 65. Dividing by halves, quarters, and thirds.

is much simpler than that used for going around the form, and you work more across the form.

Soon this simple way of looking and working will become habitual, and it will not be necessary to go into elaborate structure on the paper, for you will be sizing up the situation much more spontaneously. Then the proportions will have that strangeness so necessary to beauty.

You can also roughly divide shapes into quarters, halves, and thirds for convenience (Fig. 65). Here again you can use the edges of your paper to aid you. Those four sides of the rectangle will always be of some assistance to you. Unfortunately, they are easily forgotten. That is why I continually refer to them. *They make drawing simple.*

Awareness of the angles of your paper will not only enable you to see proportion, but also will ultimately help your sense of composition to flourish.

Proportion is closely linked with composition. The technique of "how much to how little" also provides a way of avoiding monotony. It can create interest for *you,* as the artist-draftsman, as well as for a spectator. It stimulates the eye. It is the very backbone of art.

Comparisons are said to be odious, but they are not when judging proportions. You will find that you are comparing things all the time—not only the relative sizes of shapes, but also their textures, their tones, and the light on them and around them. This desire to compare one line with another, one shape with another, is the very essence of visual perception. It also is innate. Allow it to function freely. It will develop a critical sense in you that will be valuable in assessing your own work and that of others. It will be based on sound foundations and not on idle whim.

Like most things connected with drawing, one thing always leads to another. The next step is detail.

POINT 8. DETAIL. Details are small shapes. When small shapes are repeated we call them *pattern* if they are regular, and *texture* if they are irregular.

The interest that is derived from details (small shapes) has something to do with every aspect of vision. Patterns provide an interest by moving the eye in a pleasant, regular way, and the eye is delighted. Texture appeals to our sense of touch.

Most of the things that make up our daily life are, in fact, small things. Moment by moment, whether we are aware of this or not, we live details of time—not large chunks of it. Even the scientists tell us that the universe is compounded of tiny things—atoms! We know also that if we pay attention to details, the larger issues will work better. Details in a drawing can be a constant source of pleasure and discovery, both to do and to see. As we incorporate them into everything we do, it is natural to want to include them into what we draw.

For this reason we must be very circumspect in our approach to them when we do.

Fig. 66. After a drawing by Albrecht Dürer, in which the detail is subordinated to the whole.

If we rush headlong into an orgy of small shapes we might easily become hopelessly confused. We must use a *sense of proportion* in dealing with them. Small shapes are invariably repeated, and it takes patience and skill to do them justice (the leaves of a tree, for example). If details are carelessly executed they will lose their point. Not only must the reasons for using them be sound, but they must be executed with love. Any drawing by the fifteenth-century German artist Albrecht Dürer will prove this (Fig. 66). Dürer, though a painter, drew extensively on copper and wood (engravings and woodcuts), and used water color, pen, Conté, and brush. Everything he drew, however, was full of minute details. He was a very careful craftsman and had a very sharp eye. Yet however much he loaded his drawings with small shapes, his drawings rarely look confused. The smaller shapes are always seen in relation to the larger shapes.

The greatest pitfall of using too many small shapes is to use them before you are ready. Until you have understood the large shapes, you cannot see the small shapes in relation to them. If, however, these small shapes are seen to be an adjunct and an extension of proportion they will eventually be managed with ease.

The important thing to be aware of is that *small shapes are not separate* from the other aspects of drawing. They are part of it. They are still shapes.

It is quite natural to want to load your drawing with details, and it is proper that you should do so if you want to. *But don't do so if it confuses you.* Be patient if it does. Eventually your eye will be able to absorb details, and you will find that you will use them without any strain whatever.

The points to remember are: See details as pattern (Fig. 67), or see them as texture (Fig. 68).

Fig. 67. Detail as pattern.

Fig. 68. Detail as texture.

Fig. 69. Detail as pattern and texture and emphasized for effect. Drawing by Margot Hamilton Hill.

Often details will seem to be a fusion between the two. If this is so, then decide to draw them one way or the other. Make them either pattern *or* texture, even to the point of exaggeration. You will be surprised—and delighted—at what you can accomplish in this way! (See Fig. 69.)

POINT 9. SPACE. Space in a drawing is one of the most difficult things to define or pin down. It is something that is *felt* by observation. It is not something tangible and concrete like tone or line. Many artists today are still preoccupied with the problems of space and spatial relationships, as artists have been since the Renaissance.

The problems of space relationships are difficult to solve for this reason: A drawing or a painting is done on a two-dimensional surface, whereas reality— the world about us—is three-dimensional. When we look at an object in space, we are aided by the fact that we have two eyes which give us a stereoscopic view so that we can judge distances better. If you close one eye and look around you, you will see that objects take on different dimension. The objects do not become flat, but their relationship to each other does, and it is difficult to judge the

FIG. 70. Dramatic use of light: "The Three Crosses," after a drawing by Rembrandt.

distances between them and you. The effect is something like 'a photograph, where everything is seen on one plane because a camera lens is one-eyed.

You can, however, help yourself a little to feel the space around and between objects by the use of light and perspective.

Since, for your first drawings, you are using artificial light and can place it where you wish, you can use it to emphasize space by:

—Using deep shadow to create unlimited depth.

—Lighting up the objects in the foreground to make them stand out, leaving the background dark.

—Lighting up the objects in the foreground more than those in the background, so that there is a gradual melting away into the space.

Fɪɢ. 71. Simple use of light: "The Artist's Mother," after a drawing by Rembrandt.

However, if this sort of lighting is reversed (lighting up the back instead of the front), there is no movement into space; instead there is a movement toward you, which also tends to flatten.

To create any conviction in depicting space, a contrast must be made between an object and its surroundings, between each object and its background. Lack of this distinction will tend to flatten.

If the background is untouched and the object is well illuminated so that the change between full light and full dark upon it is clearly seen (is full of contrast), there will be created the effect of space around it.

A study of the drawings and etchings of Rembrandt (Dutch school; b. 1606, d. 1669) will help you to understand this point about light and space. Rem-

brandt used light as other artists have used color (post-cubist Braque, for instance) to create space. His bold and dramatic use of tone, which often hides a wealth of detail, is of perennial interest to students of drawing. His freely drawn brush studies and fully finished etchings show how he creates space by the use of strong light and dark, usually referred to as *chiaroscuro* (Fig. 70).

Rembrandt's landscapes, interiors, and portraits are a constant source of delight and information. He may not appeal to all tastes, but if you wish to understand something about the dramatic qualities of space, look at Rembrandt's drawings.

I shall refer to Rembrandt again in another context. For the moment, I only wish to emphasize his use of light and space. Like all great artists, he was many-sided in his approach. Rembrandt used all the possibilities of light, illuminating from the front or from behind, sketching the way that best suited his composition. He sometimes used two or three different sources of light at a time, so that the mood becomes quite unearthly. But in his single portraits he used his lighting simply, either from the side or from the front, leaving the background unlit (Fig. 71).

In any case, he was a master of contrast.

TO SUM UP. Any drawing, whether in line or tone, will look flat if it lacks *contrast* in the lines or in the tones. But when considering space, the best method of all is to trust the eye. The eye will pick out quite naturally the salient points which emphasize for it the space between the objects.

Perspective is another matter. It can help us with the problem of space and with the problem of looking, but it has many snares.

POINT 10. PERSPECTIVE—EYE LEVELS. Generally speaking, the complete theory of perspective can be developed from a single basic phenomenon: *as objects recede from the eye they decrease in size.*

For example, as a railway train moving over a straight track becomes more distant, its dimensions apparently become smaller. Its speed also seems to diminish, for the space over which it travels appears to be shorter and shorter as it moves farther and farther away.

If we look at the track itself the two rails also seem to be getting closer and closer as the track recedes until at the furthest point (the horizon) they finally meet (Fig. 72).

If we then place some telegraph poles on either side of the track at equal distances from each other the height of the poles begins to shrink as they near the horizon and recede from the eye (Fig. 73).

The point where all these lines converge on the horizon is called the eye level (or viewpoint), and all lines in a drawing are affected by that viewpoint.

It is with this viewpoint, or eye level, that we must concern ourselves, because until we move outdoors to draw, we will be involved mainly with subjects

FIG. 72. Railway track in perspective.

FIG. 73. Poles by the track.

that are fairly near to us in distance: still life, interiors, figures, and such. In this kind of subject, the eye level plays the most important part.

The three points to remember are these:

1. When you are above the object, you will see more top planes (Fig. 74).
2. When you are facing the object, you will see more front planes (Fig 75).
3. When you are underneath, you will see more bottom planes (Fig. 76).

In each case you will also see the side planes as well.

If we refer to the telegraph poles and the railway track, which are seen from a mid-eye level (either above or below), it will be noted that *everything above the eye slopes down to the horizon* (Fig. 77).

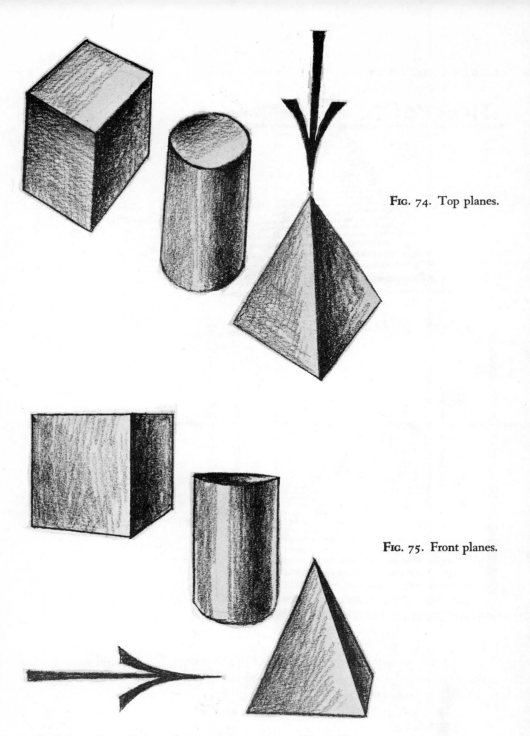

FIG. 74. Top planes.

FIG. 75. Front planes.

And everything below the eye slopes up to it (Fig. 78).

Note how this also applies to any object seen close up (Fig. 32).

These few simple facts are all you need to know about perspective for the moment. I shall touch upon other points in the section on outdoor drawing. The vital thing to remember in this: *There is no substitute for direct observation.*

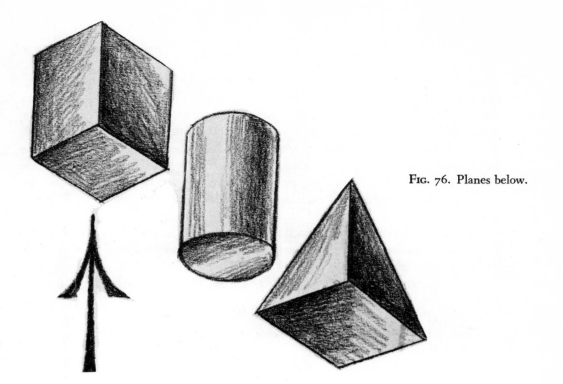

Fig. 76. Planes below.

Fig. 77. Angles sloping down to the horizon.

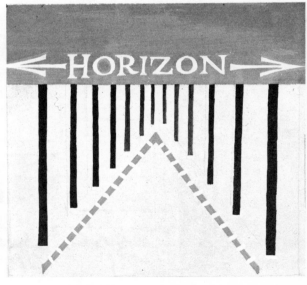

Fig. 78. Angles sloping up to the horizon.

There are those who think that a thorough knowledge of the theory of perspective will enable them to draw. This is a mistake. Perspective can aid you when your eye cannot grasp what is in front of you. But it cannot do more. If a drawing is carried out completely by the rules of perspective the result will look dead and mechanical. For this reason, "perspective drawing" is used mainly by architects to show clients what their buildings will look like when completed, or by engineers and car manufacturers to show off their new models. Perspective drawing has very little to do with art, or expression, or the discovery of visual beauty.

It is for this reason that too much emphasis on perspective theory is harmful. It can kill creativity. It would be better to ignore the perspective altogether than for that to happen.

But perspective can also be useful. It is wise, therefore, to know something about it.

POINT 11. THE SIZE OF A DRAWING. The size of a drawing must depend on:
 a) the paper available, or
 b) what is most comfortable to manage.

The paper you choose can be any size; it is not necessary to fill it entirely with one drawing. The paper can be divided by folding, or by neatly tearing or cutting it into regular sections.

One factor that has to be taken into consideration is the amount of time you have. Obviously, a large area of paper will be awkward to cover if your time is short.

FIG. 79. Size of drawings—dividing the paper into varied rectangles.

To avoid being rushed, it is a good plan to fill your paper with neatly drawn rectangles that you feel you *can* fill in the time at your disposal (Fig. 79). The smaller you make them, the quicker you will fill them.

As a general guide, however, a quarter imperial (8 by 11 inches) is a useful size for beginning. You will soon discover whether you prefer to draw in larger or smaller areas. The quarter imperial is a good average size to cover when you have more than an hour to spend.

Conclusion

In summing up this section, two things stand out clearly:

1. We see things by shape (everything has a distinctive shape that we can recognize without recourse to labels of what it is), but we draw them by tone.

It is the tone that we see on the paper—the amount of black, gray, and white will make up the image. Therefore, the simpler these tones are, the more likelihood there is that the drawing will look convincing.

2. Drawing is "made simple" when it is "kept simple."

Look for a simple answer to what seems a complicated problem. You will find that there usually is one. Try another drawing.

This leads us to the inevitable conclusion:

Quantity, not quality, should be the aim, for without quantity there will be no quality.

CHAPTER 5

HOME SUBJECTS AND FIGURES

The easiest kind of drawing to do is the one that uses subjects near at hand—the still life, for example—because objects for it can always be found in your home. But we often take for granted what is under our noses and so miss the most convenient of all sources for subjects: the home itself.

Every room in a home is rich in possibilities. This has been borne out by the way in which artists, past and present, have enthusiastically drawn or painted the everyday things around them. (See Fig. 80.) Chardin, for instance, used the kitchen as a subject in most of his work. Sometimes he showed the whole, sometimes only a part of it. He perhaps arranged a few kitchen utensils for a still life or discovered a subject already made. With figures or without figures, most of his paintings show some aspect of the kitchen.

Painters of the seventeenth-century Dutch school such as Vermeer, De Hooch, and Terborch were also intrigued by the home scenes they saw around them, and in many cases painted nothing else.

In our own day, too, we find that artists continue to turn to the home for subjects. Two French painters in particular, Édouard Vuillard and Pierre Bonnard, show us that no matter how often it is used, the home provides subjects as wonderful and as fresh as ever.

Vuillard concerned himself mainly with the living room. In his pictures, people relax, eat, read, talk, and so on. Bonnard, on the other hand, not only shows people eating, but interested himself in the cluttered table that was left afterward. He did numerous studies of used plates and dishes, haphazardly left after a meal. By doing so, he proved that beauty can be discovered in the most unlikely places.

He also went further afield—into the bedroom, and even into the bathroom, where he discovered that bathrooms were not only places in which to wash or shave but had an unexpected visual appeal as well.

FIG. 80. Study of an interior in pen and wash by Lorenzo Lotto (Italian, 1480–1556).

For a start then, the home offers these subjects:
1. The living room.
2. The kitchen.
3. The bedroom.
4. The bathroom.
5. Anything that is found in them.

All these rooms are available, whether you live in a small apartment or in a large house. If you are fortunate enough to live in a large house you will have in addition:
6. Spare or junk rooms.
7. Attics and lofts.
8. Libraries, sunrooms, and porches.

SELECTING A SCENE

To recapitulate: In daily life what we see is reinforced by memory. In the still-life groups we disregarded memory as being an encumbrance and tried to see

objects as *shapes*. We made no reference to their labels (or names). A still life is a good subject for doing this because it is simple and allows us to focus our attention on shapes alone.

With a view like an interior, the problem is again complicated by the way in which our eyes and minds behave in daily use. Unlike a simple still life, an interior presents more distraction to contend with; our focus of attention is more widely dispersed. Let us examine the reasons for this and see how they can be overcome.

THE GREEDY EYE

From time to time, the mind must cut itself off from what is going on around it. This happens, for example, when we think. But whatever we are thinking about—it may be important or trivial—we are mentally absent, at least partially, during the time. It is at this point that the eyes stand guard as sentries.

If anything important or dangerous happens the eyes must inform the mind immediately. The eyes cannot select what is or is not vital, so they convey everything. To be sure that the mind will react to the information, the eyes are forced to bombard it with visual data in excess of what is necessary.

When we set out to select a view, however, our *minds* are alert. Nevertheless, our eyes will continue to give us too much information. Therefore we must counteract this tendency by *cutting down what is seen* to manageable proportions.

TOO MUCH DETAIL

In a still life, it is a fairly straightforward problem to choose those objects that have simple shapes and simple tones. But in an interior scene, where so much is happening, the large, important shapes—those you can deal with—are likely to be obscured by irrelevant detail.

One way of cutting out what you don't want is by half closing your eyes. This will aid you to see all the important tones as well as the important shapes. It should also be resorted to while you are drawing whenever your work seems to go wrong or whenever there is any confusion caused by a change of light. Half closing your eyes is the most natural, therefore the most simple, way of "looking" for drawing.

Another way is by looking through tinted glass, or wearing tinted sunglasses. Sunglasses are very useful for outdoor drawing, but for interiors they are likely to obscure your paper as well as the subject in front of you. Outside, where the light is stronger, this is less liable to happen. (See the chapter "Drawing Outdoors.")

THE VIEWFINDER

What you draw is limited by your paper (a rectangle). Your eyes, however, have no such limitation; they have a range of over 180 degrees laterally. You are thus forced to cut down or select your view from this wider range to fit your paper.

To achieve this, you can look through any of the following viewfinders:

1. A rectangle cut out of a piece of card (Fig. 51).
2. A rectangle made with your fingers.
3. A reducing glass (Fig. 81).
4. The viewfinder of a camera.
5. A rectangular hand mirror.
6. A rectangular wall mirror.

Fig. 81. Reducing glass.

It is an easy matter to cut a cardboard viewfinder; it is even easier to use your fingers to make a rectangle. These two, then, are the simplest and therefore the most ideal methods. A reducing glass or a camera viewfinder has the advantage of compressing what is seen into a much smaller shape. But though this can be useful, it can also create problems. The view selected has a tendency to be artificial—the eye is still seeing too much, but on a smaller scale.

A hand or wall mirror is an ideal viewfinder, except that it shows everything in reverse. The seventeenth-century Dutch artists, who were very much concerned with optics, used them extensively. Mirrors served not only to select a view, but to compose it as well. In the seventeenth century, mirrors were expensive and fragile. To protect them, a curtain was drawn across them when they were not in use. This curtain can be seen in many Dutch pictures folded neatly above or at the side of the canvas. In later times, it was a constant source of mystery to experts and connoisseurs of Dutch painting, who could never fathom why it was there. Then at last the experts realized that the Dutch painters had

worked directly from a mirror and the curtain had been included to show that this had been done. It revealed a nice sense of honesty.

Mirrors have the added advantage of cutting down the amount of tone that is seen. A slightly tinted mirror is even better.

Lenses, mirrors, and tinted and untinted glass have been frequently used by artists throughout history to enable them to "cut down" what they saw. Dürer used a glass frame with lines scored upon it (something like a reducing glass). Canaletto used a camera obscura, a remarkable contraption that used a lens to project a scene on an opaque piece of glass.

In the main, with practice, the habit of cutting down will become second nature to you. You will then be able to deal with all sorts of subjects, both indoors and out, and recourse to viewfinders will become less necessary. However, the fact that some artists in the past have gone to great effort to invent all kinds of viewfinders leads one to suspect that not all artists overcome this handicap completely and have to resort to such devices from time to time. (I know I frequently squint at a view to sort it out and look through my fingers to select a focal point. However, the action is by now unconscious and I am hardly aware that I am doing it.)

How much you need to cut down will depend a great deal on the mechanism of your individual eyes. Some people have eyes so sharp that they will go on seeing too much, however hard they try not to. But as long as one is aware of this need to cut down, it does not greatly matter how it is achieved.

Exercise in a Simple View
 1. On a half imperial sheet of paper, draw some rectangles of different sizes, completely filling the paper.

 2. Select any interior view that immediately appeals to you, using a viewfinder and selecting its main tonal shapes by half closing your eyes.

 3. Do a quick drawing, using Conté or charcoal, in the first rectangle. Spend just as long as you need to fill the rectangle with a good, rich, simple statement. Ten minutes should be ample (Fig. 82).

 4. Change your view by shifting your chair or merely by turning around. But don't move far.

 5. Proceed to fill in another rectangle as before.

 6. Continue to fill in all the rectangles, changing your view each time, and if possible, spend a little longer than ten minutes to fill the larger rectangles.

Points to Watch
 1. Keep your equipment simple. All that you need for this exercise is:
 a) Drawing board.
 b) A few sheets of paper (mixed).
 c) Some sticks of charcoal and Conté.
 d) A rag to keep your hands clean.

Fig. 82. Small, quick studies of interior.

e) Two chairs: one for sitting, the other for supporting your board. (See Fig. 10.)

2. Take note of the available light to determine:

a) That your paper is well lighted and is not shadowed by your body or any other obstruction.

b) Whether you are working in daylight or artificial light or a mixture of both. Daylight fades in the afternoon. If it is seen in conjunction with artificial light, remember that as it fades, the artificial light will become the sole light and that all the tones will alter because of this.

3. Always face the view you are drawing. This is especially important if the scene in front of you is a complicated one. Avoid being distracted by something seen out of the corner of your eye. If that part of the view interests you do another drawing of it.

4. Make yourself comfortable. Also, try to be as hidden away from other people as possible. Nothing is more distracting than to be the target for every member of the household, however well intentioned they may be.

5. Avoid detail in the drawing. The small rectangles will help you to do this. Concentrate on large tonal shapes by reducing them to simple black, gray, and white tones.

6. Ignore perspective. At this stage, it is more helpful to concentrate on tone.

7. Keep lines to a minimum.

8. Fix all drawings afterward.

9. Repeat the exercise in other parts of the house as many times as you wish.

Exercise in Elaborating the View

1. From any of your small drawings, select the view that interests you most or the one that you think is best.

2. On another sheet of paper, try out that view from the same spot on a larger scale.

3. Block in the large tonal shapes as before, but add as much detail as you can manage or you think is needed.

4. Check perspective by using pencils to measure appropriate angles.

5. Keep the small sketch by you all the time.

This method of doing a small drawing first, quickly, then elaborating it in a larger version will enable you to bridge the jump from "quick looking" to "slow looking" successfully and without strain. It should be followed both indoors and out.

When you go back to the view, make sure that you do the large version from exactly the same position as before and that the lighting conditions are the same, too. If you do not you may become confused and your drawing will not be as successful as the small sketch.

THE RANDOM STILL-LIFE GROUP

A ready-made still-life group will strike your eye at the most unexpected times and in the most unexpected places. You must be ready when it takes you by surprise. You will often find it among the clutter and jumble of a garage, workroom, junkroom, or playroom. Other places that may reveal possible subjects are shelves, kitchen tables, cupboards, pantries, odd corners, and so on.

The random group makes a nice contrast to a scene. It also makes an interesting focal point if it is included in a scene (Fig. 83).

FIG. 83. Study of an interior with figures and random still-life groups (after a drawing by Edouard Vuillard, French, 1868–1940).

FIGURES

However interesting a random group or an interior may be to draw, it will be doubly enhanced by the addition of a figure or figures.

The human figure is one of the most fascinating of all subjects, as artists throughout history have shown us. Unfortunately, two great obstacles must be faced:

1. The shapes are the most complicated of all shapes.
2. Figures move.

To cope with these successfully one can:

 a) reduce the larger complicated shapes to simple ones

 b) draw quickly.

The essential factor is to be able to spot the inherent structure that underlies the human figure.

CONSTRUCTING THE FIGURE

The structure of the human figure doesn't show up as easily as that of a box or jug. The human figure is not just one form (or shape), but many forms. (See Fig. 84.) These differently sized shapes are all interrelated to function with smoothness and precision. They are so beautifully coordinated that the eye finds it hard to detect them and, consequently, is often unable to determine exactly what does go on "under the skin."

However, we have seen that to assess any complicated shape (like an object) we break the large shape down into smaller ones (see Fig. 64). This applies to

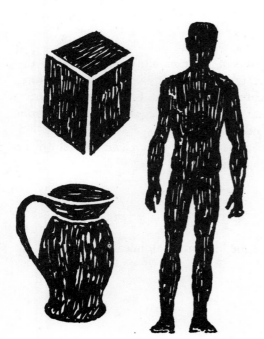

FIG. 84. Comparison between jug, box, and human silhouette.

the human figure in much the same way. But in this instance it might be thought that to do justice to the more complex structure of the figure, a detailed knowledge of anatomy is needed. Happily, the reverse is true. In spite of clothes and skin, the structure does show. As long as it is remembered that the human form has *three main divisions* only that these important divisions are considered first, a drawing of the figure will always look convincing.

The three main divisions are the head, the shoulders and chest, and the hips (Fig. 85).

FIG. 85. The head, shoulders and chest, and hips.

The arms, legs, hands, and feet, because of their mobility, are generally the cause of the confusion that is encountered when setting up a drawing. Therefore, they are best ignored until the main structure is put down. Once the main structure has been dealt with, you will see that the arms and legs take their cue from the way the head, shoulders and chest, and hips behave.

Only a small amount of anatomy need be known, which can be helpful or illuminating to basic study of the three main divisions.

SIMPLE ANATOMY IN CONSTRUCTING THE FIGURE

The head, the shoulders and chest, and the hips are anatomically called:
 1. The skull (Figs. 86, 87).

Fig. 86. The skull (front).

Fig. 87. The skull (side).

Fig. 88. The thorax (rib cage).

Fig. 89. The pelvis.

2. The thorax (Fig. 88).

3. The pelvis (Fig. 89).

They are all connected by the spine (Fig. 90).

It is unnecessary to make a detailed study of these bones as long as their *characteristic shapes* are remembered. They can be reduced to the simple shapes of an oval and two unequal rectangles for easier understanding (Fig. 91). It will

Fig. 90. The spine.

Fig. 91. Basic shapes of head, thorax, and pelvis.

Fig. 92. Male pelvis from side.

Fig. 93. Female pelvis from the side.

FIG. 94. Comparison between male and female thorax.

FIG. 95. Stating the three elements.

FIG. 96. Standing pose: angle of pelvis.

be noted that the female pelvis is larger than the male pelvis and is inclined at an angle, but the thorax of the female is smaller (Figs. 92, 93, 94).

If the angle and position of these three elements are stated first the pose will follow naturally (Fig. 95).

FIG. 97. Standing pose:
angles of head, thorax, pelvis,
and how the arms and legs
are affected.

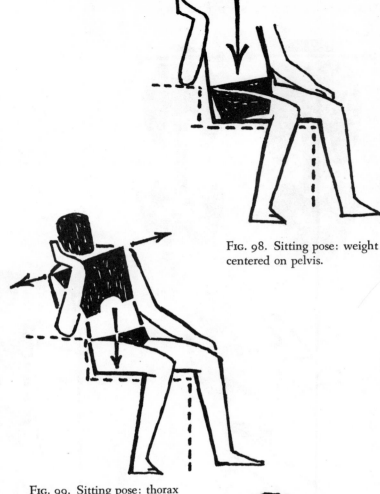

FIG. 98. Sitting pose: weight
centered on pelvis.

FIG. 99. Sitting pose: thorax
and head.

FIG. 100. Action pose.

FIG. 101. Walking pose.

The legs and arms are conditioned by what the three main divisions are doing, but also affect them in turn. For example, in a standing pose, the pelvis is angled when the weight is taken on one leg (Fig. 96).

The aim of a good figure drawing is to capture the particular action or pose that has been taken. You may think that because the main action of the pose is being done by an arm lifting or a leg kicking, all you need is to get that arm right and the rest of the pose will follow. Unfortunately, it doesn't quite work out that way. Most likely the arm will lift and the leg kick, but the rest of the figure will have collapsed. Any action of the arms and legs will affect the skull (head), thorax, and pelvis as they, in turn, will affect the arms and legs. But, as a general rule, the action of any pose begins with the three main divisions.

In a standing pose, the angles of the thorax and pelvis are affected by which leg is taking the weight (Fig. 97).

In a sitting pose, all the weight is centered on the pelvis and this time the pelvis will influence the position of the legs (Fig. 98). In turn, the thorax and the head are affected too, and so finally are the arms (Fig. 99).

In a strong action pose where the action is taken up by the arms, the pelvis and the legs follow that action (Fig. 100).

In walking, running, or stretching poses, the same principles apply (Fig. 101).

Muscles. A thorough knowledge of the superficial muscles tends to make drawing the human body complicated. Inevitably, confusion results. Also, such specialized knowledge will deflect natural progress rather than aid it. For those who have a scholarly bent and a desire to increase their knowledge of human anatomy, there are many good textbooks which will satisfy them. But in general, as a beginner, you need not worry about it and can trust your own eyes, as long

FIG. 102. Male and female silhouettes.

as you are aware that the *male* shape is angular and the shoulders are wider than the pelvis; the *female* shape is more curvilinear, the shoulders are narrower than the pelvis, and the shoulders slope more than in the male (Fig. 102). As these main differences are patently obvious anyway, a study of muscles will be a waste of time.

The Undraped Figure

Similarly, the study of the nude figure is less important than one may be led to believe.

The study of the nude was once an integral part of an artist's training. It was commonly known as "life" drawing, and art students spent hour after hour doing it, under the impression that if they could draw the nude they would automatically become bona fide artists. Unfortunately, as events proved, the opposite was true. Instead of live drawings they produced dead ones. For many years, dull and lifeless drawings were made until it was realized that the best way to study life was in life itself, that is, in the natural everyday actions of people. Because of this, "life" drawing is not insisted on nearly as much as it once was.

If you look at people in normal daily routine you see them at their most natural and therefore at their best. In a life art class, the model is posed in a bare setting and consequently takes up a frozen position that is quite unnatural. As a result, an air of unreality permeates both the drawing and the student. Working under such conditions is a strain. Yet these were the conditions in which students were expected to study the human figure still may be in some schools. It is hardly surprising that after years of work under such conditions, drawings never seem to improve.

Students today, however, are more fortunate than our unenlightened forebears, who were forced to spend their time enclosed in life classes because convention demanded such rigid and unattractive measures when drawing the nude. There was something slightly shameful about it. Our times are less prudish; we can go anywhere and see very lightly clad people, both young and old, at swimming pools, beaches, and so on. There we can study them in all their unrestricted vigor and movement, and see all the simple, natural poses they take up in pleasant natural surroundings.

But generally we see people clothed. Therefore, a study of the draped figure should be of more value to you than the nude studies.

The Draped Figure

The two main points to look for are:
1. The position of the head, thorax, and pelvis.
2. How the clothes are arranged over the latter two.

Clothes will always take on the form of the structure underneath. They also have one other characteristic: They fall into folds. The folds must be looked for last. Often they tend to more or less obscure the forms underneath, and this must be borne in mind.

The folds can be studied separately. A coat or jacket may be hung over a chair or on a hook (Fig. 103); a shirt, blouse, or skirt may be arranged on a table, like a still life. Or a simple piece of cloth like a towel or sheet may be crumpled up and then drawn (Fig. 104). Drapery is not only fascinating to draw but also makes fascinating drawings (Fig 105).

Fig. 104. Crumpled cloth.

Fig. 103. Jacket.

Folds look more convincing if their structure is emphasized. The characteristic look of a fold is better shown when it is crisply stated (Fig. 106). The more simply folds are drawn the more real they look. If too many variations of shape are attempted the result more often than not looks like chewing gum or old rags.

During the Renaissance in Italy, when the study of drapery was of paramount importance, the drapery was dipped into plaster before it was arranged to give it monumentality and grace. As it dried, it fell into stiff, crisply formed shapes which could then be studied with greater ease. The use of plaster also had the advantage of fixing the subject, for drapery is easily disturbed and as a result loses its shape.

FIG. 105. "Woman on a
Swing," by Jean Antione
Watteau, showing drapery
worn.

FIG. 106. Accentuating folds
by drawing them crisply.

FIG. 107. Study for an angel by Fra Bartolommeo (Italian, fifteenth century).

FIG. 108. Obscuring the form: eighteenth-century costumes by Margot Hamilton Hill.

The conclusions drawn from this practice still apply. Make the folds more like molded tin—and they will succeed, paradoxically, in looking like graceful folds.

Contemporary clothes, however, obscure what is beneath them less than did those of the past, where voluminous drapes often enclosed the figure completely (Figs. 107, 108). Today's clothes hug the figure more; consequently the underlying form shows up better (Fig. 109). This is all to the good. It proves how practical some of our dress is. This is something to look for when drawing figures.

FIG. 109. Fashion drawing
by Margot Hamilton Hill.

FIGS. 110, 111. Modern
clothes.

Be sure that the clothes that are worn really "work" (Fig. 110) and don't just look as if they happened by chance. Trousers, jackets, skirts, and so on should give the impression that they are really being *worn* by their owners. If this is keenly observed, it will also bring out the character of the person concerned. For each one of us wears his clothes slightly differently, according to his own personality (Figs. 111, 112).

ARMS

The arm can be divided into three sections: the upper arm, the lower arm, and the hand.

A single line broken at the elbow and again at the wrist is all that is needed to give an arm's basic structure (Fig. 113).

The arm is generally covered by some form of sleeve, and this can be shown in the same way (Fig. 114).

The sleeve is like a soft cylinder through which the arm goes; it bends where the arm bends (Fig. 115).

FIG. 112. Modern clothes enhancing personality.

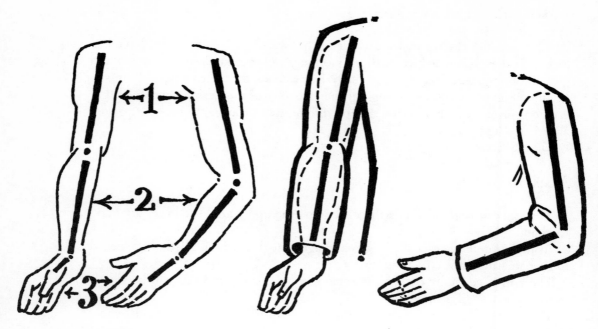

FIG. 113. Three sections of
the arm.

FIG. 114. Arm in a sleeve.

FIG. 115. Bend in sleeve.

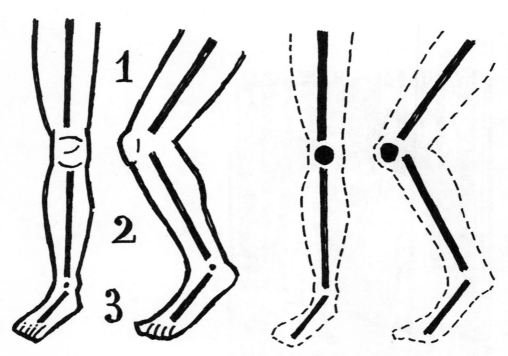

FIG. 117. Basic structure of
the leg.

FIG. 116. Three sections of
the leg.

FIG. 118. Leg inside trouser.

LEGS

Legs, too, can be divided into three sections: the thigh, the calf, and the foot.

Apart from shape, the main difference between the arm and the leg is the knee, which has a patella, or kneecap, to protect the joint (Fig. 116). Also, the foot is not nearly as flexible at the ankle as the hand is at the wrist. Nevertheless, a single broken line also gives the basic structure (Fig. 117). Trousers, like sleeves, are flexible cylinders and can be constructed in the same way (Fig. 118).

Hands and feet, however, are a little more complex.

HANDS

The human hand consists of units that have a number of functions to perform. The units are: the fingers, the thumb, and the palm (Fig 119).

These units can do a great many useful and expressive things. It is the speed at which they do these things that makes the hand a seemingly difficult object to see clearly.

There is an old and mistakenly held idea that if you can draw a hand you can draw anything. But the reverse is just as true: if you can draw anything you can draw a hand!

FIG. 119. Units of the hand.

FIG. 120. Moving and unmoving parts of the hand.

FIG. 121. The action of the thumb.

FIG. 122. Structure through joints.

FIG. 123. Thumb opposing fingers.

FIG. 124. Structure of the hand.

A hand is capable of performing complex actions, but if it is looked at as though it were an immobile bunch of bananas, you will see that the complexity is deceptive.

The hand can be divided into the moving parts: the fingers and thumb, and the unmoving part: the palm (Fig. 120). The action of the fingers opposes that of the thumb. This is why we can do so many things with our hand that animals, who lack a thumb, cannot (Fig. 121).

Human fingers work to a definite rhythm and show a general similarity of construction, although they differ in size. It will be seen that whatever position the hand takes up, this regularity can always be plotted by stressing it through the joints and knuckles (Fig. 122).

The thumb, being separate in activity, is then much more easily seen to take its proper place (Fig. 123).

The problem is one of *small shapes* (the fingers), which oppose another small shape (the thumb). With a little practice in reducing the hand to these shapes, you will find the hand quite easy to draw (Fig. 124). The superficial, or surface, qualities like the veins and creases, lights and darks, and so on will always look convincing if the basic structure is tackled first.

FEET

Feet are not dissimilar to hands, except that possibly they are easier to see because they move less. They are made up of one large shape and five smaller shapes (Fig. 125).

In the foot, however, it is the large shape that is more complex. The arch and the ankle are the cause of this, and they must be reduced to their simplest forms before the small shapes (the toes) are drawn (Fig. 126).

Once this basic structure is understood, drawing feet is quite simple (Fig. 127). The toes are regular in construction, and except for the big toe, they are similar to each other in shape.

FIG. 125. Units of the foot.

FIG. 126. Construction of
large shape, front.

FIG. 127. Construction of
large shape, side.

FINGERNAILS AND TOENAILS

The nails give the final characteristic look to hands and feet, *but they must be drawn in last,* with the knuckles, creases, and so on. The shape of nails varies with each individual and must be noted carefully. Invariably, they curve around the finger, thumb, or toe very slightly. They have the look of being *inserted* into the fingertip, rather than being part of it. (See Figs. 123, 127).

GLOVES AND SHOES

A glove is virtually a jacket for the hand, and if it is studied as either a piece of drapery or another still-life object it can be of great assistance to you in grasping the fundamental structure of the hand (Fig. 128). Because of the interesting shapes that gloves make, they are always a useful addition to a still-life group.

Because most of your subjects will be shod, not barefoot, it is important to learn to draw shoes. A shoe can be studied both on the foot and by itself as a still-life object (Fig. 129). A shoe varies, depending on whether it is a man's, woman's, or child's shoe, but the structure is essentially the same in every case, even though the shape may differ (Fig. 130).

If the shoe is treated like any other object and is broken down into angular

shapes and proportions, you will see that not only is it a fascinating subject, but quite a simple one as well.

There are two good reasons for drawing gloves and shoes: They are very interesting subjects in themselves and they are useful aids to drawing hands and feet.

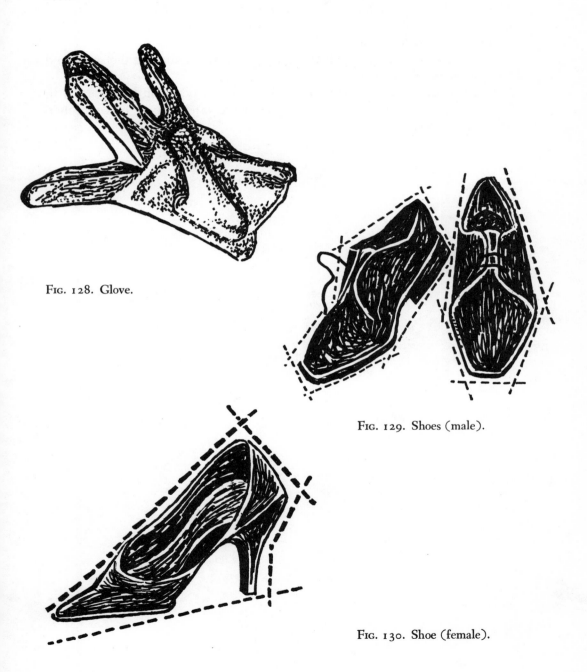

FIG. 128. Glove.

FIG. 129. Shoes (male).

FIG. 130. Shoe (female).

INTERIOR WITH FIGURES: CONCLUSION

These are the important points to remember:

1. It is unnecessary to make the figure dominate the scene at the beginning.

2. Use a natural pose: sitting, reading, sewing, or simply standing.

3. Let the scene dominate. It is unnecessary to show all of the figure. Of course, if you are doing a portrait, the head will dominate.

4. Use as few figures as possible.

5. Always arrange the available lighting so that it enhances the scene and shows clearly what you want to be seen.

6. Avoid any violent action poses. (This type of pose will be discussed in the section on outdoor drawing, since it is more often found in connection with outdoor scenes.)

DRAWING PORTRAITS

Portraiture is one of the most engaging studies. Because of the variety of sub-jects available, it is a kind of drawing that one never tires of doing over and over again. But it can be frustrating.

The fascination of portraits comes from dealing with a number of wonder-fully interrelated shapes. The frustrations come from something outside draw-ing.

The causes of these frustrations have to do with the way in which most people react to the human face. Whether we are aware of it or not, we react far more *emotionally* to faces than to most of the other things we draw. Therefore, if these relations are not clearly understood they will tend to come between us and our sitter and distort our vision.

How are we affected by a face? How will our reaction to it affect our draw-ing?

In a still life we can look at a jug, note its shape, its tone, and how it ap-pears under different lighting conditions—and that's about all. But a face is capable of expression: sadness, dignity, humor, and so on. It can also be "beauti-ful" or "ugly." The features—nose, eyes, mouth—will convey personal traits; so will the way the sitter behaves.

We will react emotionally to all these things, one way or another. In daily life this is quite natural. But we must be a little more detached when drawing.

With a still life, we can be detached more easily because our emotions are not involved in the same way. Therefore, we can freely note tones, shapes, and lights, and drawing the still life is straightforward and enjoyable. However, it is much more difficult to note the shapes, tones, and lights in a portrait when, instead of looking for those qualities, we are constantly making character judg-ments or being attracted or repelled emotionally by the way the sitter looks or behaves.

The qualities of human dignity—so essential to a good portrait—will emerge more naturally in the drawing if we are detached. So will other characteristics,

from a good likeness to forms beautiful in themselves. Our personal reactions are more likely to be integrated into the drawing if we do not wholly rely on them to dominate our drawing. If we allow them too much scope they will produce a conflict which will, in turn, affect our drawing. The result is frustration.

Constructing a Head

A portrait is not just a face. A portrait is a *head*.

A head has, for example, a top (usually covered with hair), sides (where the ears are), a back (hair and neck), and an underneath (chin).

A portrait is the sum of all these things. Broken down in this way it will be seen that the basic structure can be contained in a cube (Fig. 131).

If the head is lighted from the side, it will also become evident that the features—eyes, nose, mouth, and chin—are additions, indentations, or projections of that cube.

The eyes are set into sockets under the brow (Fig. 132).

The nose projects (Fig. 133).

The mouth projects slightly (Fig. 134).

Underneath, the mouth indents.

The chin projects (Fig. 135).

The ears are additions (Fig. 136).

Completed head (Fig. 137).

FIG. 131. The head contained in a cube.

FIG. 132. The eyes.

FIG. 133. The nose.

Fig. 134. The mouth.

Fig. 136. The ears.

Fig. 135. The chin. Portrait by Ghisha Koenig.

Fig. 137. Completed head: "Portrait of Peter B." by Margot Hamilton Hill.

The head can be constructed with cubic shapes (Fig. 138) or tonal shapes (Fig. 139) to begin with, then refined into *particular* shapes afterward (Fig. 140).

Fig. 138. Cubic shapes.

Fig. 139. Tonal shapes.

As in a still life, the details should be added last. These character-making details of the face—eyebrows, nostrils, lips, ears, and so on—should always be left until the very end. It is a temptation to put these details in rather early. It should be resisted until the structure of the head has been thoroughly "seen" first. If they are tackled too soon it will make drawing a head difficult. If, on the other hand, they are put in *after the structure has been blocked in,* it will make portraiture simple.

The head is a bony structure with movable parts: the jaws, the eyes, eyebrows, mouth, and so on. It will soon be realized that a head is *not* a flat shape with features. A child draws only the face part because he reacts completely emotionally. He is perfectly satisfied with this fragment. His drawings have a charm and a quaintness, but are also, paradoxically, emotionless (Fig. 141). If the head is always seen in its entirety first—with its complete structure—the result will be emotionally deeper and richer.

A portrait depends on this structure to "hold up" the features, much as iron girders hold up a building. The structure need not be apparent, but it must be

Fig. 140. Portrait by Hans Holbein (German, 1497–1543).

there underneath, otherwise the features will float about or else look flabby and uncertain. The result will be completely unconvincing.

On examining the portrait drawings of such masters as Holbein, Dürer, Rembrandt, Goya, and Picasso, one can see how much they depended on this structure (Fig. 142).

Holbein, a prolific portrait draftsman, used very little tone in his drawings. Nevertheless, the bony structure is "felt" throughout his drawings. Though he concentrated on highlighting the eyes, nose, and mouth, they are always firmly

FIG. 141. Child's portrait by
Stephan Daniels (age seven
years).

FIG. 142. Portrait by Goya
(Spanish, 1746–1828).

held by the delicate structure underneath. (Sometimes the structure is so deli-
cate that one can be deceived into thinking that it isn't there at all—but it is, as
anyone copying a Holbein drawing will discover.)

TO SUM UP
1. See the head as a whole.
2. Block in the main structural shapes.
3. Leave the features (details) until last.

LIGHTING A HEAD

Lighting a head is not radically dissimilar to lighting a still life. The same
principles apply. The only departure will be to arrange the light so that it brings
out the character of the sitter. If the sitter has a clear-cut face a harsh side light
will accentuate it (Fig. 143).

A soft, round face needs a gentle top light or a gentle front light, with a few
reflected shadows (Fig. 144).

A dramatic effect can be obtained by placing the light below (Fig. 145).

FIG. 143. Harsh light:
portrait by Gerard David
(Flemish, 1450–1523).

FIG. 144. Gentle front light:
head by Andrea Verrocchio
(Italian, 1435–88).

FIG. 145. Light underneath:
based on a drawing by
Daumier.

A harsh top light accentuates the eye sockets and the jaws (Fig. 146).

As lighting is an aid to bringing out character, it should be considered carefully. Experimenting with it can be exciting and rewarding (Fig. 147).

FIG. 146. Harsh top light:
self-portrait by Giovanni
Bernini (Italian, 1598–1680).

FIG. 147. Back lighting:
portrait by Emilio Greco
(Italian, contemporary).

BACKGROUNDS

The background behind a portrait should be kept very simple. The focus of attention should be on the head alone. If the head is set against a complicated background it will be disturbing to draw and to look at. Select a background tone to accord with the character of the sitter. Dark backgrounds are more dramatic than light ones. Light backgrounds are softer, more gentle, but tend to throw the head into silhouette (see Figs. 30, 147). For general purposes, a background that is neutral in tone and light is simplest.

The Sitter

As well as contending with our own emotions, we will have to contend with those of our sitter. But the first consideration should be practical: his or her comfort.

All the details that contribute to the sitter's comfort, from the kind of chair he is sitting in to the light—which should not be in his eyes—are important and help toward the making of a good portrait. And these things must be seen to before you begin. *The sitter must be relaxed* from the very beginning. If not, his tension will be conveyed to you and will affect your drawing.

These are the points to bear in mind:

1. Be sure that there is no stray light shining uncomfortably into your sitter's eyes. This can become unbearable after a few minutes, and will be upsetting both to the sitter and you.

2. Encourage your sitter to take a natural, comfortable pose by talking or joking with him and putting him at ease. Before you begin, make sure the pose he has adopted *is* comfortable and will not set up muscle tensions later on. Otherwise he will squirm and move about, which will make it hard for you to concentrate. Under such conditions good drawing is impossible.

3. Do not overtire your sitter with long periods of posing. It is a terrible strain to sit for hour after hour (however relaxed) without any chance to move around. Confine your sittings to twenty-minute sessions at the longest, with a good five minutes of rest in between. More than anything else, this will create better relations between you and your sitter and will probably make him eager to sit for you again.

The Artist and the Sitter

The other sensitive area in the relationship between artist and sitter concerns the sitter's emotions about the portrait. To what extent has the sitter any right to express them, to interfere with the progress of the portrait—or even to decide on its final form?

The question is: Who has final authority on what kind of a portrait it should be—the artist or the sitter? Should it tell the truth as the artist sees it, or should it sacrifice that truth to flatter the sitter? The history of portraiture reveals how this conflict has affected artists in different periods, and often the answer has depended on the artist's integrity. Throughout the ages, artists have either succumbed or rebelled. Obviously, their first task was to achieve a likeness to the sitter. Beyond that, they were faced with the choice of simply flattering the sitter or expressing their own feelings toward the sitter. In many cases, artists ignored or completely rejected their own reactions; in other words, the sitter piped the tune because he paid. And usually if the artist succumbed—because he was too timid to do otherwise—his work became routine and lifeless.

Galleries and museums are filled with portraits of this type. They are known as "official portraits." They were done to flatter the ego of the sitter—to make him appear greater, grander, or more beautiful than he really was. As a result such portraits are invariably dull.

In the museums of today there are hundreds of sculptured portraits of retired Roman generals, pompous emperors, highborn ladies—and they all look pretty much alike. There are court paintings (commissioned by monarchs) of the people who drifted in and out of palaces—like the pictures of Charles the Second of England—and these people, too, are indistinguishable one from the other.

There are portraits known as "family portraits," commissioned by those who wished to perpetuate their likeness (and the family honor) for posterity. The world is full of such portraits. They are given an important place in some homes, yet nobody is moved, nobody really cares.

These stereotypes are not portraits. They are lifeless copies. Unless the artist insists on being the final arbiter of how a portrait will look, the portrait will fail to come alive. And if a portrait fails to come alive it will have been a waste of time—either to do or to look at.

It is because of his solution to this dilemma that Rembrandt is held in such high esteem. In his youth, Rembrandt found that it was an easy matter to make money by painting groups of successful Dutch burghers and their wives who, proud of their newly found independence, freedom, and wealth, wished to be immortalized for posterity. The motives of these good folk were quite natural. They even went to the extent of choosing the most talented and promising painters of their day. They had no wish to be artistic Philistines. On the contrary, they were the people who encouraged art. But when it came to a portrait, they demanded a good pose (which meant a grand pose), a good light (which meant that they would be shown off to the best advantage), and no nonsense (which meant any sort of imagination or visual truth was taboo).

The result can be seen in Rembrandt's "The Anatomy Lesson of Dr. Tulp," commissioned by the doctor as a memorial to the surgeons' guild. After its completion, Rembrandt, already well known, became the most celebrated painter in Holland.

As for the painting, it is dull, theatrical, and empty. In it, seven would-be doctors pompously pretend to be interested while the professor snips the exposed brachial tendons of a corpse. Unfortunately, they look like stuffed actors frozen in a stage photograph. And the patrons loved it.

Yet Rembrandt was a genius, as his later works were to prove. In this, and in many other portraits painted at that time, he tried to reconcile the irreconcilable. In this instance, the demands of his artistic conscience and the demands of the surgeons' guild met head on and produced a striking horror that puzzles us even today.

In the painting "The Night Watch," however, Rembrandt was to make a

different choice. When the painting was commissioned by Captain Banning Cocq, commander of the civic guards, Rembrandt was expected to produce a picture containing a series of orderly portraits nicely grouped together (rather like any college or sports photograph today), intended to show the pomp and dignity of the military. Sixteen of the civic guards willingly contributed toward this expensive item, which was to hang in the Hall of the Musketeers. To a man, they unanimously voted Rembrandt to do the job. For their pains, they received the biggest shock of their lives.

Rembrandt decided once and for all that he would paint his portraits the way he wanted to. The result was one of the world's masterpieces. But it was also the end of Rembrandt as a "face" painter in the popular sense. After that, the tide of favor went against him, and though he continued to paint many great and lasting portraits, he was never again commissioned to paint an expensive one like "The Night Watch."

Rembrandt had made the only choice open to an honest artist—to trust his eyes and his inspiration. And though he ceased to be rich, he became, instead, a greater artist.

I have gone on at some length about Rembrandt because the surprising fact remains that until "The Night Watch" was painted few artists had ever dared to outrage the wishes of their sitters so flagrantly. Rembrandt paid the price, of course. But the artists who followed him gained a tremendous advantage in their battle for the right to do their work according to the dictates of their own consciences and abilities. It is a freedom to be jealously guarded and judiciously used.

SOME SIMPLE EXERCISES IN PORTRAITURE

1. Place the sitter in front of a jet-black background with a strong and simple side light. For the moment, ignore the character of the sitter and make the light as strong and positive as you can without discomforting the sitter. Draw the portrait and the black background to the edges of the paper (Fig. 148).

2. Using the same background, place the light more to the front and light up any shadows with a reflected light (Fig. 149). The object of these exercises is to familiarize you with the head as a shape (Exercise 1), and the head as a shape within a space (Exercise 2).

3. Try out a head with a medium-toned background, using the same lighting as above (both side and front), to see how the shape is modified by the background and by the lighting.

4. Now try the head (again using both kinds of lighting) against a dead white background. A piece of white paper will do or a sheet. Note the differences.

These backgrounds are the three basic tones: black, gray, and white, and are

the least subtle. But if you limit yourself to these until you see how they affect the head it will be a short step to then see the head under more natural conditions, and to arrange lighting and backgrounds that will enhance your sitter and help to bring out his or her character.

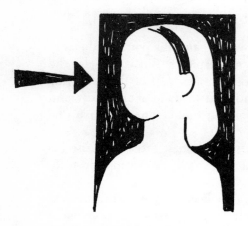

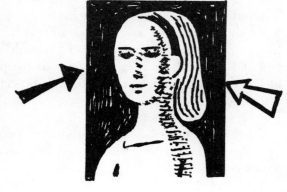

FIG. 148. Portrait with black background.

FIG. 149. Portrait with black background and reflected light.

CHAPTER 7

DRAWING OUTDOORS

SCENES THROUGH THE WINDOW

This important subject can be drawn in the comfort of your home; it has been deliberately omitted from the list given in Chapter 5.

The reasons for this are:

1. It is a little more complicated than an interior and should only be tackled after some experience with interiors.

2. It makes an excellent introduction to outdoor drawing, but can be done under more comfortable circumstances than drawing outdoors.

3. It enables you to study changing light.

In an exterior view there will be a great deal more going on than you have dealt with before. There is more detail. The range is wider. On the other hand, because of the changing light, it is more exciting. You will find that almost any window presents a view packed with interest. Outside scenes viewed from windows on different floors also bring up the problems of perspective at different levels. These levels should be varied as much as possible. If you are fortunate and have access to upstairs and downstairs windows you should use every one of them. It will provide valuable experience for you later, when you begin drawing outdoors.

Because of the wealth of material in an exterior scene, the simplest way to begin is to use the windowpane as a sort of frame. Use either the whole pane or, better still, if the window is divided into small panes, use only one of them (Fig. 150).

If the window is divided you can work fairly close to the glass, using the pane as a viewfinder.

If your window is not broken into panes you can move back, so that you don't get too broad a view outside the window.

After the first few drawings, it will be easier to ignore your "pane frame" and move closer to the window; using a card viewfinder to pick your scene.

Try using the view through the window as a part of an interior scene. Try

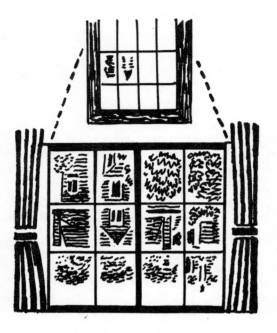

FIG. 150. Drawing through a window.

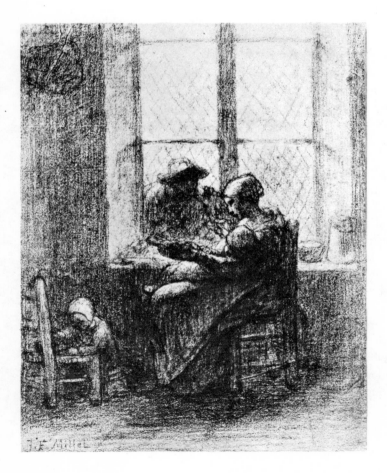

FIG. 151. Figure in front of a window by J. F. Millet (French, 1814–75).

drawing figures in front of the window so that the silhouettes they make provide a contrast to the view outside (Fig. 151).

Drawing the view seen through a window is interesting, but limited. It will serve to whet your appetite, however, until you are able to go outside to draw. But even if you step out into the garden (another home subject, really) there are a few practical considerations which should be taken into account.

It is natural that anyone who has been drawing for some time should want to extend his range and subject matter. Then why not just take some paper and a few crayons, go outside, and begin?

On the face of it, the advantages of drawing outdoors are enormous. You can vary your scene, find unusual places, come across all kinds of weird and wonderful objects. It is refreshing to work outside if you have been confined inside all week. A sense of exhilaration accompanies drawing outdoors that cannot be experienced in any other way.

Then why not go right outside and begin at once?

Of all the subjects you can choose, outdoor drawing requires the most careful preparation beforehand. If any one of the practical considerations is neglected, if there is any carelessness in your preparation, then the results will be disappointing and you will feel frustrated. And then you may never again want to draw outdoors—which would be a great pity, for of all subject material some of the best is found outdoors.

Indoor Versus Outdoor Practice

Indoors you can allow a certain amount of latitude in the way you organize your methods.

1. You can settle yourself comfortably by choosing the right chair or desk.

2. You can arrange the room temperature.

3. A large supply of materials can be stored away. This means you have a wider selection to choose from and there is less likelihood of running out.

4. Though you should always lay out just what you will need, any omission can be easily rectified.

5. You can work comfortably on a drawing of any size.

6. Work can be left unfinished in the knowledge that it will be safe until you get back to it later.

Outside, the situation is entirely different. In each instance mentioned above, the reverse is true. You can't always arrange or find a comfortable spot to work in. You cannot control the weather. Your choice of materials is limited to what you can carry with you (it isn't always possible to carry large quantities). The size of your paper is limited outdoors. Often it is impossible to return to the same place to complete unfinished work—and so on.

The key phrase to remember when you plan an outdoor session is: *Be practical —don't leave anything to chance.*

This section will deal, therefore, with all the possible contingencies you might meet. It will deal with equipment and preparation. It will discuss where to draw and what to do.

Like all things connected with drawing the basic needs are small. But everything mentioned is essential. Since all your materials will have to be carried in something, we begin first with a paintbox or carrying case.

The Paintbox

The paintbox is not only going to hold all your materials, but you are going to have to carry it as well.

When you go into the country to draw, it is unlikely that you will always find just the right spot as soon as you arrive. At times you will probably want to walk around to explore. If you use a car it usually isn't sufficient to pile your materials in the back with the idea that when you stop all you need do is to take them out and begin. You may sometimes have to walk quite far to get just the view you want or to vary the view you have. But no matter how you look at it, you must keep your materials handy in a convenient box or bag that can be carried comfortably.

These are the points to look for when choosing a paintbox or bag:

1. It should be light and easy to carry.

2. It should be large enough to hold sketchbook and materials (inks, water pot, crayons, pencils, rag, etc.) without letting them get jumbled up together, which would cause quite a mess. Your materials should fit snugly into the bag or box so that it will not be lumpy or uncomfortable to carry.

3. It should be well made. A cheaply made carrying case will wear out quickly. It may also break when you are out and therefore be irritating to carry. It is even more annoying if the case or bag should come apart and scatter your materials all over the place. Test each part carefully: straps, seams, and fabric or material.

4. A practical case need not be too large. A good size is 17 by 11 by 2 inches.

5. By far the most comfortable is one that can be carried on your shoulder. Try to avoid anything that has to be carried in your hand, as this is most tiring.

6. The box or bag should be so designed that nothing can fall out easily.

If these points are taken into consideration you will have a good, practical carrying bag. This is an important piece of equipment. It should be carefully chosen and cared for.

The Sketchbook

The second most important item of equipment is the sketchbook.

When you go out drawing, it is advisable to use something lighter than a board and paper. For one thing, carrying a board is tiring. It is also clumsy to hold. For another, sheets of paper get lost, dirty, or flap around in the slightest wind. There is almost never a comfortable place where you can prop your board or keep it safe. The board invariably gets damaged; the paper becomes crumpled.

Under these circumstances, it is much more practical to use a sketchbook. But sketchbooks have a number of advantages as well.

1. Sketchbooks can be stored easily. Because they are in book form, they can be kept on a shelf when full and are readily available for quick reference.

2. All the work you do is kept conveniently together. As your sketchbooks pile up, they chart your progress and indicate different developments that have taken place.

3. Your sketchbooks provide a record of the places you have seen and of how you felt about them.

4. They contain potential future reference material on objects and things you have seen and recorded: plants, trees, animals, skies, water, and the like.

5. Sketchbooks are also a form of autobiography. There is no limit to the personal things you can keep in sketchbooks. You can put into them ideas, notes, jottings, doodles, exercises, your copies or reproductions of drawings you have admired—even photographs can be stuck in. In short, they need not be used only for drawings done outdoors; anything personal that you feel like putting in can go into them. It is entirely up to you.

Keeping a sketchbook can be fun.

A good sketchbook should have these qualities:

1. It should not be too large. Sketchbooks come in all sizes, which serve different purposes. For inside work, you may want to use a large book instead of separate sheets of paper. Outdoors, a large book would be impractical. A good average size would be about 7 by 14 inches, give or take a few inches either way. They can be vertical or horizontal. The three most common sketchbooks are vertical, horizontal, and pad. A 7- by 14-inch book should fit most carrying bags comfortably without taking up too much room. You can do a fairly large drawing by working across two pages.

2. It should not be too heavy. Anything that adds weight unnecessarily should be discarded for something lighter. A heavy sketchbook not only adds weight but is awkward and heavy to hold. A heavy book usually has too many pages, thick paper, and thick covers.

Strong covers and strong papers need not be thick. Nor is it practical to have a great many pages. Books with many pages take a long time to fill, and while you are filling it, the book is under great strain and more liable to damage. No

book, however well made, can stand up to the wear and tear of being carried around indefinitely. Therefore, a thinner book (about thirty pages) is sufficient.

3. A good sketchbook should be firm to hold, with stiff covers. This means that it will stand up to normal wear and tear. Generally, a good sketchbook costs a little more than a poor one, but the extra expense involved is usually worth it.

4. The type of binding used on sketchbooks varies. The most usual are spiral, sewn, or glued.

Both the spiral and the sewn bindings hold together under reasonable working conditions. With care they will remain intact indefinitely. In the glued type, the pages come apart rather easily; they are pads rather than books and should be retained for use inside rather than outdoors. They have many advantages for inside work that are lost when taken out of doors.

5. As we have said, paper can be of all types and tints. It should not be too thin, however, or it will not wear well (see the section on paper). It should not be too thick for reasons given.

White paper of a medium grade (not too rough or too smooth) is generally the most practical at the beginning. You can experiment with tinted and rough surfaces later. For this you will find that quite a number of books are made up with varied kinds of paper. Some are all tinted, others have a mixture of white and tinted.

A simple homemade sketchbook can be made up with an assortment of papers cut to size and clipped into two strong covers (Fig. 152) or sewn like a book.

Fig. 152. Homemade sketch-book.

Care of Sketchbook. The point of keeping a sketchbook is that all the work you do outside is contained between two covers. Unless you are careless and lose the entire book, the separate drawings will always be intact, kept together neatly and safe from loss or damage.

Therefore, though it is easy to tear pages out of a spiral-bound book without harm, you should resist the temptation. The great value of keeping a sketchbook will be in leaving intact everything you do, whether it is good or bad, completed or not. Retaining everything you do will aid your development. Every scrap of drawing you do is another step in the ladder of growth. If you tear out one sketch you will disturb the sequence of your development.

To aid you in keeping a growing sketchbook:

a) Date all your drawings.
b) Keep the drawings in sequence.
c) Start at the beginning of the book always, never in the middle.
d) Work through it consecutively.
e) Keep all the drawings right side up.
f) Use both sides of the paper if possible. (Note: Some papers may not take a drawing on both sides. Thin papers tend to show through and spoil the drawing on the other side, so check your paper carefully for this.)
g) Never tear out a drawing, either to frame it or give it away. Do another drawing from it instead. (See the section on composition.)
h) Vary your approach: Do drawings of different sizes, alternate your mediums, use a little color here and there—and feel free to experiment. If a page becomes loose fix it back in again right away.
i) If the binding should tear or split mend it immediately.
j) Above all, put your name and address inside the front cover of your sketchbook, so that if it is lost you stand some chance of having it returned.
k) Always complete the book to the last page, even if you intensely dislike what you have done in it. Play about, literally mess up the pages —anything to fill the book up. This will ensure that you never get a complex about a book by being precious about it. On the other

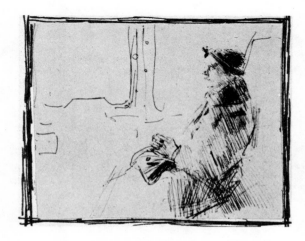

Fig. 153. Sketchbook drawing by Fredrick Cummins.

hand, it is just as restricting to be overcareful, too tidy, and miserly with the pages. Therefore, make a point of doing one or two really messy or experimental drawings. This will not only encourage your development, but will make your sketchbook much more exciting to look at (Figs. 153, 154, 155).

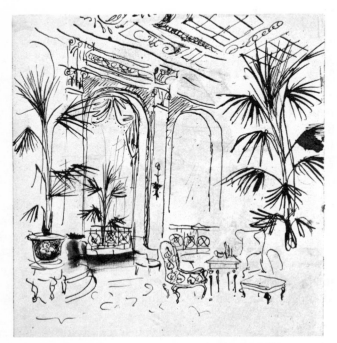

FIG. 154. Sketchbook drawing by Margot Hamilton Hill.

FIG. 155. Sketchbook drawing by Pablo Picasso (Bullfight series).

Pocket Sketchbooks

It won't always be possible for you to go out with a large sketchbook and
a paintbox full of materials. It is possible, however, to keep a small sketchbook in
your pocket. This you can fill at odd moments, working with pen or pencil.
These notes, or even finished drawings, can be of inestimable value. They can
be left intact in your little book or quite easily remounted in a larger book.

You will also find that in some situations it is much more convenient to use a
small book. For example, while waiting in a bus or railway station you can study
and sketch people in action. It is a simple matter to slip out a small book sur-
reptitiously and begin drawing without anybody being aware of what you are
up to.

It is an excellent rule never to go anywhere without one. You never know
what unusual things you may run into. It is also a good way of practicing. If you
can acquire the habit of drawing at every available opportunity it will speed
your progress enormously.

Making Yourself Comfortable Outdoors

When you go out into the country to draw, you will need very little to support
your sketchbook. You can hold it easily in your hand or rest it on your knee (Fig.
156). Any kind of easel would be an encumbrance. The easels that you com-
monly see being used outdoors are usually supporting canvases for oil paint-
ing.

Fig. 156. Supporting sketch-
book.

Finding a comfortable seat for yourself is another matter. It is not always pos-
sible either to stand or sit down comfortably on certain sites. A small folding stool
or a foam-rubber cushion is helpful, though you must remember that these extra
things can be annoying to carry around. If possible, they should be eliminated.

MATERIALS

You can take any of these materials out with you:

> Pencils (carbon and lead).
> Pens (fountain, felt, etc.)
> Crayons (Conté, wax, etc.)
> Chalks and pastels (for color)
> Charcoal (for quick sketches)
> Water colors or diluted inks for washes (see Chapter 8)
> Brushes

You will also need:

> Rag
> Water pot (and water) for washes
> Clips or elastic band for holding down pages
> Knife or razor blades for sharpening

Except for the rag, knife, clips, and sketchbook, the rest need not be taken out all at once. Choose a selection that can be varied from time to time.

For example, carbon pencil and red Conté are enough to begin with.

Or, as an alternative, black Conté, diluted ink wash, and brushes; or black ink, diluted ink, brushes, and pens; or carbon pencils, colored ink, and a pen; or colored inks, a few crayons, brushes, and pens.

The variety that you can obtain by combining just a few of these mediums is quite amazing. But there are a few points to watch.

Crayons, chalks, pencils, and charcoal are messy and should be kept in separate boxes to ensure cleanliness and avoid breakage. If they are kept loose in your paintbox they will make a mess of both it and your sketchbook.

Diluted ink for washes can be made up before you go out.

Keep stoppers on ink bottles when you are not using them; otherwise the ink will evaporate very quickly outdoors. Check the bottles carefully when you put them back into your carrying case to make sure that the stoppers are firmly in, so that there is no possible chance of leakage. A leaky ink bottle can ruin a sketchbook beyond repair and does your paintbox no good either.

Rags are very useful for cleaning brushes, pens, and your hands. They can also be wrapped around the ink bottles to make doubly sure of avoiding accidents.

WATCHING THE WEATHER

Not everyone lives in a climate that is sunny throughout the year, and so it is a good idea to keep the weather in mind when you plan a sketching expedition. Be prepared for any sudden unexpected change in the weather; sometimes it

only takes a few hours to turn very cold or for a thunderstorm to come up. So try to check the weather forecasts before you go out—especially if you intend to go far. Have a light raincoat handy. Wear good, heavy shoes. Cold or wet feet can kill your enthusiasm quicker than anything. If you think it may turn cold suddenly wrap up warmly.

If, on the other hand, the weather is hot and sunny, wear something to protect your eyes and head from glare, or find a spot under some shade. It is quite unnecessary to martyr yourself in the cause of art. And the likelihood is that your effort will be wasted. You are bound to do better if you are comfortable than if you are suffering. *Any form of discomfort should be avoided.*

Where to Draw

Outdoor drawing is exciting. It also engages more of your energies than working inside. All your faculties will be used to the full. Therefore, it would be far better not to attempt too much right away.

It is wise, then, to acclimatize yourself by working as near your home as possible at first. If you have a garden begin there. Outdoor drawing demands a great deal of concentration. There are many distractions to contend with in addition to the main problem of drawing, and you should try to minimize them if you can.

The Place. Choose quiet spots, if possible. If this is difficult try to be as inconspicuous as possible. This is a habit that can soon be acquired. By spotting the best hide-outs and making for them, you will soon be able to find places where you are not noticed at all.

Choose simple views at the beginning. Avoid complicated subjects which are so crowded that you become confused. Later, when you have some experience, you will be able to tackle them without any trouble at all.

Check that the place you have selected is dry and won't be flooded after you have begun. This applies to rivers, fields, swamps, and marshy areas. Make sure you are welcome and not trespassing and be certain that there is no danger from falling stones or bricks, and the like.

Some of the most exciting subjects are found around docks, quarries, mines, freight yards, city market places, harbors, and so on. These places can be hazardous, and you would do well either to get permission to work there or to make absolutely certain that it is safe to work there. Once you become absorbed in your drawing, you may be unaware of any approaching danger.

This is why it is a good plan to begin near home. The places you are familiar with will provide more opportunity for you to get used to all the new art problems that will confront you. It is better to limit yourself to *short sessions* at first. A page of small drawings is quite enough. As you acquire more confidence, you can lengthen the time spent.

WHAT TO DRAW: SUBJECT MATTER

As you become more familiar with drawing outdoors, you will find that your interest will shift from the pleasant subjects like trees, landscapes, rivers and so on, to the more bizarre and atypical places like salvage yards, wastelands, oil dumps, swamps, shipyards, and so on. These unlikely places appeal because, more often than not, the best subject matter stands out more than it does in "nicer" places.

Any subject is a good subject, and at first the best subject is the one that appeals to you. But as you develop, you will want to widen your horizon further still, and it is the most unlikely subjects—those that seem to repel—that often have the most interesting shapes, tones, and textures. Those who wish to explore must not be put off by the fact that a *place* may be ugly or unpleasant. *It is the shapes, tones, and light we draw, not the associated ideas we have about them.*

It is these *visual* qualities—tone, shape, light, texture, pattern, proportion—that must determine whether you choose that particular place or not. The judgments of "beautiful" or "ugly" made by others should not affect your choice.

SIMPLE EXERCISE IN OUTDOOR DRAWING

Take a small sketchbook (one that can easily be put in your pocket), a piece of Conté or a carbon pencil, open your front door, and look out.

Draw a few rectangles about 2 by 3 inches on the first page. Fill in the first rectangle quickly with what you see (Fig. 157).

Then walk outside, stop somewhere convenient, and do another quick drawing. For this exercise, it is unnecessary to spend longer than five minutes on each drawing.

FIG. 157. Simple exercise: filling in small rectangles.

FIG. 158. Simple exercise: completed.

Continue walking and drawing as long as your energy permits. Give up as soon as you feel tired, or if conditions make it difficult to continue (change of weather, nowhere to stand or sit comfortably, etc.). Then return home and look at what you have done.

Above all, don't *choose* what to draw. *Do the first thing you see.* Choosing what to draw is tiring. It is easy to fall into the habit of wandering around "looking" for something "nice" to draw. It was Picasso who said: "I do not seek —I find." This is sound advice. A quick survey of the country around your home will reveal all kinds of unexpected things, which may have escaped your notice. Outdoor drawing is finding—not seeking, and to find one must accept the first thing seen, put it down, and walk on (Fig. 158).

The first few attempts may reveal very little, but as you continue, what you find will become more and more revealing.

This exercise should be repeated again and again, either in a small or large sketchbook.

Before beginning a large drawing, it is a good idea to survey your site first by doing a series of small, quick drawings of it. From them you will not only be able to choose the best view, but also because now that the view is familiar to you, you will feel more at ease with it and will be able to do the larger picture more comfortably.

This need not take long, and the time you spend doing these small sketches will prove more than worthwhile in the end. If you just wander about hoping to discover something interesting you never seem to; once you begin working, you invariably do.

INSIDE AND OUTSIDE

There is one fundamental difference between drawing indoors and outdoors: space.

Inside, the space is enclosed; therefore, it is easier to define. Outside, it moves in all directions with few boundaries. Looking through a viewfinder will help to

Fig. 159. Limitations of a viewfinder.

cut down and contain what is around us, but it cannot contain what recedes from us (Fig. 159).

Therefore, *before* using the viewfinder we must take receding space into consideration. When this is done, it is a simple matter to look through the viewfinder and see all the important shapes in their proper relationships to one another.

DIVIDING RECEDING SPACE

Every recession in space is *always* made up of a foreground (Fig. 160), a middle ground, or middle distance (Fig. 161), and a background (Fig. 162).

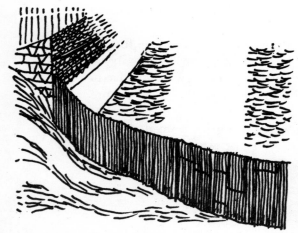

FIG. 160. Foreground.

FIG. 161. Middle ground.

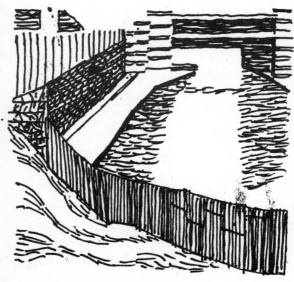

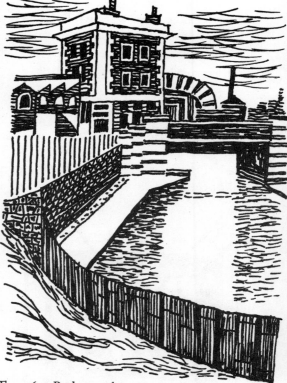

FIG. 162. Background.

Foreground. The foreground is the part that is closest to the eye. It may be filled with objects (Fig. 163) or it may be empty (Fig. 164).

If any feeling of space is to be emphasized the foreground must be carefully considered as part of the drawing. It can easily be overlooked. It is not uncommon to take for granted what is *directly* in front of us and to concentrate on what is in the middle distance. For example, when driving a car, we "look ahead" at the objects that we are moving toward. Basically, we do the same thing when walking, though we are moving at a much slower rate. We become so used to doing this that we develop a subconscious awareness of the nearby things, but we ignore them. If we ignore the nearby objects when we draw, however, the effect will invariably *flatten* the space.

Therefore, if we reverse this tendency and take the middle distance a little more for granted, it will correct the balance and help overcome this problem (Fig. 165).

Build your view on the foreground by blocking it in first. Then look through or around it to see where the middle ground and background lie in relation to the foreground. But use the foreground all the time. It is the first important factor in dealing with outdoor space.

FIG. 164. Foreground empty.

FIG. 163. Foreground filled.

FIG. 165. Taking middle ground for granted. Pen drawing by Havar, Yugoslavia.

FIG. 166. Completed foreground, middle ground, and background. Country church (brush and ink).

Middle Ground and Background. Once the qualities of the foreground have been established, the middle ground and background elements will be seen to fit into their respective places quite naturally (Fig. 166). After establishing the foreground, understanding the middle ground is the next important step. For example, if we look at the whole picture in terms of tone the foreground usually has the strongest contrasting tones, the middle ground has medium-strong tones, and the background tones are the least strong (Fig. 167).

This also applies to detail, which is clearer in the foreground, less so in the middle ground, and often completely lost in the background (Fig. 168).

Finally, the same principle applies to the subjects seen. If there are a great many objects in the foreground there will be fewer in the middle ground and background (Fig. 169). If there are more objects in the middle ground there will be fewer in the foreground and background (Fig. 170). If there are fewer objects in both the foreground and middle ground most of the things seen will be in the background (Fig. 171).

But in each case, though there may be many objects in one, the others must not be neglected (Fig. 172), or the space will immediately become flattened (Fig. 173).

Fig. 167. Tones: Foreground, middle ground, and background. London canal (wash).

FIG. 168. Clear detail in the foreground. Seton Street market (rapidograph).

FIG. 169. Foreground blocking view. Dubrovnik market (pen).

FIG. 170. Strong middle ground. Camden town (Conté).

FIG. 171. Background. Snowdon, North Wales, seen across Lake Padan (brush).

FIG. 172. Dubrovnik market (pen).

FIG. 173. Flattened space.

All this will be quite obvious once you become aware of it. The reason why we may not have realized this before is because for practical purposes we have learned to think differently in daily life. When we draw, we reverse that process and change the habits we have acquired.

No matter what you see in either the foreground, middle ground, or background, a great deal will depend on the *position* from which you see it, or your *eye level* when you look at a scene. It is this eye level that is the key to the problem of perspective outdoors.

PERSPECTIVE OUTDOORS

The perspective of everything you see depends more or less on the position of your eye level when you see it: whether you look down on it from above

(Fig. 174), look up at it from below (Fig. 175), or whether you are on the same level with it and see it directly ahead (Fig. 176).

The thing to remember is that nobody looks at anything with a fixed or rigid stare. When you look at a view, you move your head and your eyes over the whole scene. Therefore, any theory of perspective must be a little short of true if it does not take this fact into consideration. Yet most theories of perspective do not. They rely on a rigidly "fixed" viewpoint. Without this fixed viewpoint most of them could not exist. This can be confusing to someone relearning how to draw.

Perspective theory tells us, for example, that verticals must always be drawn perfectly vertical. Yet when we look about us, we can see that this is not so. Ver-

FIG. 174. Perspective: above.

FIG. 175. Perspective: below.

FIG. 176. Perspective: straight ahead.

ticals lean this way and that, depending on how our head is tilted. Horizontals look as if they bend slightly (Fig. 177).

As any book on theoretical perspective will tell you, all lines converge at an imaginary vanishing point (Fig. 178). This is all very well for some people, but have *you* ever *seen* a vanishing point? When we draw, we must concern ourselves with the actual, not the imaginary or the theoretical, if we are to get the most out of drawing. Once again: Trust your eyes to do the job for you, not a theory.

Therefore, if you check angles you are unsure of by the use of a pencil you are bound to be "right."

If you notice whether you are above or below your subject that is all that is necessary. (See Figs. 174, 175.)

FIG. 177. Optical variations on horizontals and verticals.

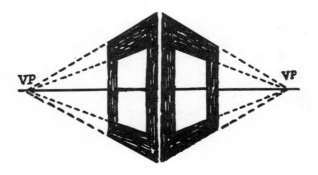

FIG. 178. Imaginary vanishing points.

If, in spite of all checking and making allowances for this and that, your draw-ings still look odd or unreal, you must bear in mind that this is *how you are see-ing things*. It will do no good to force yourself to see like someone else or like a photograph. If you are to develop at all you must accept what emerges on paper and avoid bringing in other standards of judgment. These will interfere with your desire to express yourself. All the fun will go and you will cease to progress.

LANDSCAPE AND TOWNSCAPE

You will be more aware of perspective in a town than in the country. One is more conscious of it in the lines of the roads and the roofs of flanking buildings because these lines sweep down to the eye level or horizon (Fig. 179). But

FIG. 179. Roads and roofs.
Pen drawing by Havar.

Fig. 180. Railway siding (Conté).

Fig. 181. Country village by Rembrandt (pen).

there are other differences of emphasis as well. In a town, one is aware of any rises or dips in the ground. The simple lines of the road will clearly define this (Fig. 180). In the country, however, these are obscured by any number of things: fields, hedges, hills, and so on (Fig. 181).

In a town, the space is cut up into blocklike shapes (Fig. 182). In the country, the space is more indeterminate. It is therefore essential to select your foreground more carefully.

In a town, the space is usually cut off by walls, which simplifies what you see by focusing attention on one or two points. In the country, the space is more dispersed, therefore attention will be dispersed as well, unless a focal point is stressed (Fig. 183).

FIG. 182. Car park (brush and ink).

FOCAL POINT

FIG. 183. Focal point in landscape.

Be aware of these and many other differences, for it is when these differences are stressed that the particular liveliness of direct outdoor drawing comes into play. It is a quality that cannot be counterfeited. It cannot be dreamed up out of the imagination. It can only happen when you are looking at nature straight—and noting the differences.

SUNLIGHT

Outdoors, light is either direct or dispersed. When the sun is not obscured, its light will fall upon everything obliquely. The planes that are facing the sun will be light; those that move away from it will be in shadow (Fig. 184).

When the sun is obscured by clouds or is setting beyond the horizon, its light will be dispersed. Thus the planes will not be as clearly defined. There will be more diffusion in the tones (Fig. 185).

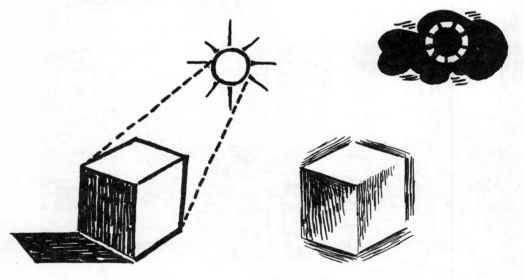

FIG. 184. Sunlight: planes facing sun.

FIG. 185. Sunlight: obscured sun.

Direct Sunlight. As the sun moves across the sky, the planes that face it will vary. In the morning and evening the light will come directly from the side, or on a more horizontal angle to most objects (Fig. 186). As the sun reaches its zenith, the light will fall more on a vertical angle from above. In certain regions, it will shine directly overhead (Fig. 187).

In the main, objects nearest to the eye will show this light relationship more clearly than those in the middle ground and background.

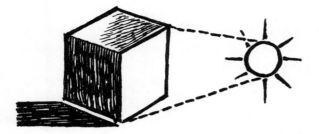

Fig. 186. Sunlight: side.

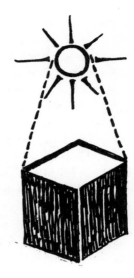

Fig. 187. Sunlight: overhead.

Direct sunlight also causes most objects to throw strong shadows on the ground. This can lead to visual confusion. If the shadows are many, there is a tendency to "overblack" them in and make a heavy, contrasting drawing, which can look muddled. In a drawing, as in a photograph, too many shadows can destroy any subtlety in the shadows.

It must also be constantly borne in mind that the sun is moving, and so the

Fig. 188. Facing into the sun: railway siding (Conté and chalk).

planes will seem to move as well. As the sun moves, different planes will be facing it. To those who find this makes drawing difficult, the best plan is to do several fairly brief drawings, in order to get down just the plane that is showing before the light moves to another plane.

The ideal position when drawing is to have the sun behind you. Then everything is brightly lit and there is a good balance between the lights and darks.

The most awkward position for drawing is to sit facing the sun. Then everything will look rather dark, with just the top planes showing a little light (Fig. 188). This can also be rather trying on the eyes. A fierce light from directly overhead can be painful, too. Many people suffer from the glare of the strong, vertical rays of direct sunlight, and even the best sunglasses are not sufficient to eliminate this completely.

As a general rule, it is less trying to limit yourself to short sessions when drawing brightly lit subjects. For a longer session, when you want to elaborate a drawing, for example, it is more comfortable to work in a dispersed light.

Dispersed Light. In a dispersed light there is only one major question when positioning yourself: Is it light enough to see everything fairly clearly? If the sky is too cloudy the light will be poor and may cause eyestrain. At dawn and dusk the light will be feeble, too, and only a quick drawing should be made.

Beyond these considerations, there is little to worry about. If the planes do not show up clearly, use plenty of simple tones, or concentrate on line alone—emphasizing surface detail instead of strong planes.

After a while, a subtle plane will reveal itself. The eye knows how to detect this without a great deal of strong sunlight to aid it.

Color

It is never a good idea to use too many colors when drawing outdoors. The following reasons explain why this adds difficulties that are unnecessary:

1. Using color takes up more time than using monochrome.

2. It means carrying more equipment.

3. Color is complicated outdoors because of the shifting light. The light is always changing, and those changes cannot be dealt with as swiftly in color as with monochrome.

4. The color you use will look different when you take it indoors. Its tones change inside—invariably they look too bright and "jump."

You should use, at the most, two touches of color and then only to enhance what is basically a monochrome drawing. A touch of color here and there will be more than enough to give the impression that a great deal of color has been added.

This is another great thing about drawing—it *can* look as if it has been

painted. It is a mistake to think that painting means the use of colors. In fact, many of the greatest paintings have very few colors. They are mainly mono-chromatic, with touches of color strategically placed to give a "colorful" look.

If, for example, there is a great deal of blue in your scene all the blue can be touched in with a crayon or wash, *but nothing else.* The rest will be drawn in the usual way.

Or if there are small patches of, say, red, these can be put in after the drawing has been completed. It is amazing how many spots of one color you will notice. It will also help to sharpen your sense of observation. You can do this with tones as well, by noticing all the very dark tones and putting them in first, for ex-ample, then the medium tones, and finally the light tones. If you prefer to see them as color instead, this will be all to the good. Everything is colored. As draftsmen, we have to reduce things to tone in the end. We can get a sense of color back into our monochrome drawing without using a great many assorted colors.

Constructing Trees

It seems very likely that wherever you go you will see trees of one sort or another, and that they will crop up somewhere in your drawing. At this point it would do no harm, therefore, to analyze the structure of a tree, so that when you need to draw one it does not represent a problem.

The "appearance" of a tree can be deceptive. In many cases it is seen as a mass of details—leaves and branches—and tends to give the impression of such multi-plicity that it is difficult to do justice to it.

This is not so. It is true that a tree is built up with tiny units (leaves), but underneath them there is a firm and easily recognizable shape—the trunk and branches (Fig. 189). The trunk and branches are like the skeletal structure of

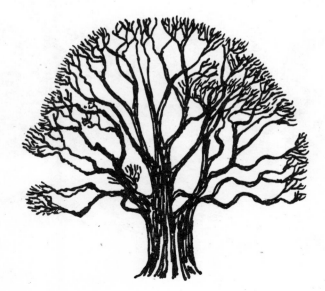

FIG. 189. Trunk and branches of a tree.

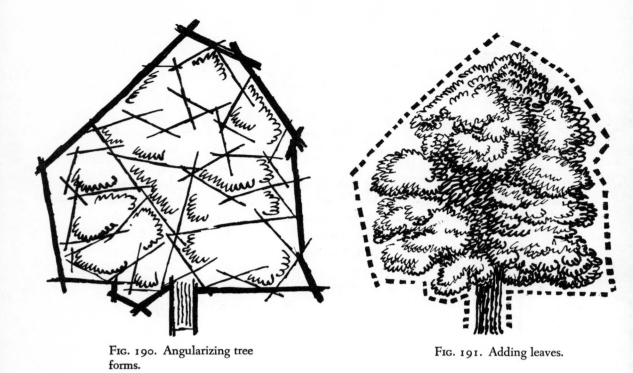

FIG. 190. Angularizing tree forms.

FIG. 191. Adding leaves.

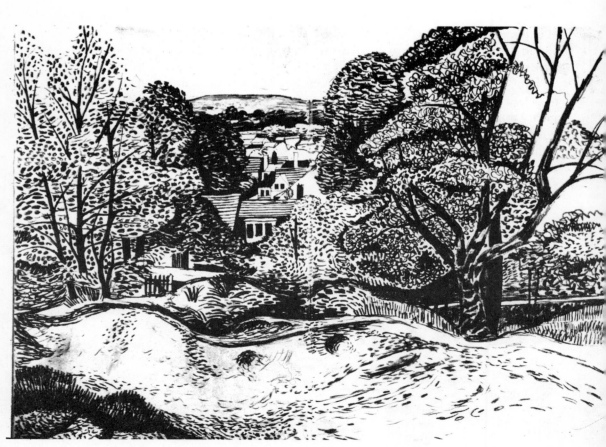

FIG. 193. Trees as textured shapes.

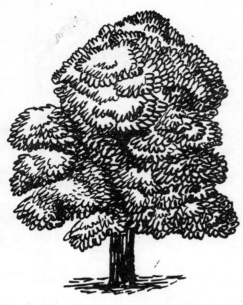

FIG. 192. Completing tree with darks, spaces, etc.

FIG. 194. Trees as shapes. Wash drawing by John Constable (English, 1776–1837).

Fig. 195. Trees: branches and trunks, Hyde Park (Conté and wash).

the human body, only in trees this skeleton shows itself for six months or so of the year.

Therefore, one way of studying trees is by concerning yourself with the trunks and branches and *adding the leaves later*.

But what if you come across a tree that is so rich in foliage that very little of the structure shows? Or how do you draw a group of trees—which seem a mass of leaves and little else?

In this instance, we fall back on angularization, much as we would do for any complicated form (the human body, for example). It will be realized that angularizing a tree is not half as difficult as it may appear (Fig. 190). In the first place, it is not necessary to be at all accurate about it. As *long as some attempt is made to register the larger shapes* the rest will fall quite naturally into place (Fig. 191). Then it is a matter of placing in the darks and spotting the leaves (Fig. 192) or merely leaving the leaves as groups of textured shapes (Fig. 193).

A great deal will depend on the available light, of course. The important things to remember are:

Go for the shapes and ignore the leaves (Fig. 194).

Bear in mind the trunk and branch structure underneath (Fig. 195).

WATER

Everything in nature seems visually complicated at first glance. Nature tends to guard her secrets so closely that one is inclined not to delve beyond the surfaces of things. Trees, for example, are complex at first sight, but when the many small shapes that together make up a tree are reduced to one or a few large units of shape nature gives in completely and nothing ever seems visually confusing again.

But how, you may ask, does this apply to *water*? On the face of it, there seems little shape to water. If there is little shape to be *seen*, then there will be no help from angularization or other techniques. There does not seem to be any way to pin down visually the elusive, changing quality of water. But there is.

What is water, visually? Water is like glass—*it reflects*. But because it does not have a silvered base, as a mirror does, it reflects at a *lower tone*. Therefore in a perfectly still pool, it will reflect exactly what is above it, but *the reflection will be darker in tone* (Fig. 196).

But water also moves, and so will the reflection.

FIG. 196. Simple reflection in still water.

FIG. 198. Reflections in moving water.

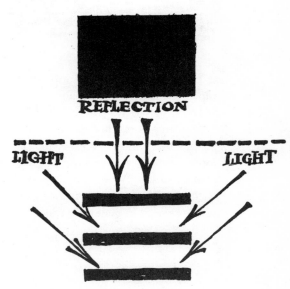

FIG. 197. Light on moving water.

This is the most important thing water does. The question is: How does this movement affect the reflection?

When movement takes place, the surface of the water breaks up into tiny facets which reflect *at a slightly different angle to each other,* rather as if you had broken a mirror and someone had stuck the pieces together, or like tin that has been crumpled and not completely straightened (Figs. 197, 198).

If the movement of water is slight the facets will reflect what is around the water quite clearly, but *somewhat broken up* (Fig. 199). The visual image will look smashed.

Fig. 199. Broken reflections.

In fast-moving or choppy water, this reflected image will be changing so rapidly that it will probably be lost. All that will be seen is a general reflection of the sky, which is by far the most dominant reflection there is.

If water is studied from this standpoint it will then be possible to see it as shapes once more. They will, of course, be smaller shapes. They will also be more transitory, always changing and apparently elusive. When this happens, *concentrate only on a small part of the water.* Once that has been established, it will be a simple matter to put in the rest. The patterns made by this breaking up of the reflection generally repeat themselves all over the surface.

People

People outdoors are rather like water in one respect: They move. Somehow, whenever you see someone take up an interesting pose, he moves as soon as you begin to draw, or else you look down to make a mark and when you look up again your subject has disappeared completely. Or perhaps you see someone who is moving all the time—walking, for example.

It will take a little time before you can get used to all this. As an aid to *slow-ing down* what people do so that you can come to grips with their movements, it is better to begin by drawing people sitting somewhere, in cafés, parks, waiting rooms, and so on, and to do it as surreptitiously as possible. Somehow people have a sixth sense about being drawn. As soon as they become aware that some-one is drawing them they will either move off or become belligerent. It is an easy matter to embarrass people by catching them unaware and drawing them. It is more tactful to keep your activities as secret as possible.

As soon as you are confident that you can tackle action poses, these are the points to bear in mind:

　　1. Look for simple shapes (Fig. 200).

　　2. Avoid detail until later (Fig. 201).

　　3. Look first, draw afterward, even if the person has gone away (Fig.202).

　　4. Don't rely on a second look. Get as much absorbed as possible while the person is in view.

　　5. Add details, like cut of coats, hats, shoes, features, etc., *from anybody around who looks similar.*

FIG. 200. Figures in a factory by Ghisha Koenig (rapidograph).

FIG. 202. Group by Ghisha Koenig (rapidograph).

FIG. 201. Figures by Margot Hamilton Hill (ballpoint pen).

FIG. 204. Quick drawing of moving figures.

FIG. 203. Crowd.

6. Make a composite figure, building it up from an arm here, a head there, a hat and coat from elsewhere (Fig. 203).

7. Draw quickly, worry about finishing later (Fig. 204).

8. Rely on your memory. Don't force yourself to remember what this or that person looked like. Just draw on top of what you have done and it will look very convincing because your memory will supply all that is needed.

9. If you want to get a variety of poses draw crowds. Any crowd that is concentrating on some particular event will be easier to draw because there is less movement. In a market place, for example, you will find that most people take up similar poses if they are watching something happening. Concentrate on one person and you will see that when he moves off and someone takes his place, he will take up an almost identical stance. You can then carry on drawing where you left off, superimposing one person on another.

PEOPLE IN PLACES

Places tend to dominate people. The interest engendered by a landscape or townscape is so great that without being fully aware of it, you may find that the people have been overlooked. This tendency should be avoided if possible for these reasons:

1. People give *life and movement* to a place.
2. They give the setting *a sense of scale*. The relationship between a figure

FIG. 205. Figures in a setting. Tower of London (brush and ink).

and its surroundings is complementary. There is no doubt left as to how high buildings are or how large a landscape is. This is important when the setting is grand and spacious. A figure accentuates this quality. Without it, the place could be of any size (Fig. 205).

3. Figures accentuate the *character* of the place. The clothes that are worn and the activity that goes on all heighten the atmosphere (Fig. 206).

4. A depopulated setting appears eerie and dreamlike. This will, no doubt, apply to certain places, but to apply it to all reduces them to monotony.

Figures need only be indicated, they need not fill the whole drawing (Fig. 207). Should figures play an important part in the view—too important to leave out, yet too awkward to put in—they can be added later. Draw the setting without them and do a separate drawing of the figures only, then combine them in an entirely new drawing. (This method of combining a series of drawings into one is discussed in Chapter 9.)

Generally speaking, you will find that it is common practice to make separate drawings of figures and then add them to a setting. This way of drawing figures is usually done in a small sketchbook with a pen or brush. Somehow these two tools produce the kind of marks needed to catch the quick, fleeting movements of people. Pens and brushes, of course, can do a great deal more, as the next chapter will show.

FIG. 206. Greek peasant.
(pen).

FIG. 207. Figures in a setting.
St. Paul's, London (pen,
brush, and ink).

CHAPTER 8

PENS AND BRUSHES

PENS

A pen is an instrument for writing or making lines with ink. The earliest writing instrument was probably the stylus, a pointed bodkin of metal, bone, or wood. It was used for producing incised or engraved letters on tablets covered with wax or clay. Much closer to our idea of a pen was the calamus which was made from hollow tubular stalks of grasss growing in marshy ground. Hollow joints of bamboo were similarly used.

The other type of writing instrument was the quill. It was made from a goose feather shaped into a nib at the unfeathered end (Fig. 208). It was by far the most successful writing implement until the introduction of steel pens. But though feathers were easily procured, shaping was a chore and the points did not last. Quill pens gave a delightful line but were easily worn out or broken.

It was not until 1809 that a machine was developed to make quill points.

FIG. 208. Quill.

These were made very much like the nibs of today and could be inserted into a holder, but since they were still made of quill they did not last long either.

Flexibility as well as strength were the prerequisites of a good pen, and the first steel pens that were introduced in 1803 were certainly strong, though not flexible. They were expensive and the demand for them was small. In 1822, a practical pen was made and a version developed by Joseph Gillott in 1831 has not been improved since. Gillott's nibs can still be bought and are world famous for their flexibility and strength. They are ideal pens for drawing and are sold as such.

The process by which a nib is made is too lengthy to go into here; suffice it to say that a great deal of care is taken to ensure that they will provide durability and working ease.

But however strongly a pen is made today, it must be treated with care. In fact, the more you allow the pen to "draw for itself," the better will be the result. A pen that draws only fine lines should not be forced to make broad ones, or a stiff pen that can only make unvaried lines forced to give varied ones. *Any undue pressure exerted on a pen will strain the delicate points and reduce its efficiency.*

The major weakness in a pen is caused by the split tip. This split is necessary so that the ink will be conveyed smoothly to the paper. In a modern pen the split tip is carefully made for strength and durability. However, if it is misused it will bend or break.

Because of this tendency, every type of nib should be tried out. We do not all have the same hand pressure. We use our fingers to hold implements in various ways for reasons of comfort. Those who have a light touch will find fine, flexible nibs perfectly satisfactory, but for those whose touch is heavier, a more robust nib will be required. You cannot know what suits you best until you try as many pens as possible. Since nibs can be bought separately from their holders, this need not be as expensive or troublesome as it may appear. Nibs don't usually cost much, and one holder will do for them all. On the other hand, a fountain pen can be expensive and selecting one is a problem.

Fountain pens avoid the need to replenish the nib with ink, which so spoils concentration. But a fountain pen that flows continuously without any leakage is invariably expensive. While you are in the process of finding a suitable pen, you do not want the burden of added expense and frustration.

So, at the beginning, it would be better to avoid fountain pens, whether they are made specifically for drawing or not, and to concentrate on nibs and holders.

Types of Pens

Gillott's make a number of drawing pens called variously lithographic (Fig. 209), crow quill (Fig 210; this needs a special holder), mapping pen (Fig.

211), and extra fine (Fig. 212). These are all rather flexible and make a variety of marks.

Another sort of pen is usually known as a lettering pen. This has a broader tip and is either flat (Fig. 213), oblique (Fig. 214), or rounded (Fig. 215). It comes in various widths and is very good for experimenting. You will usually find that the larger lettering pens have a tiny clip, which is attached underneath to hold the ink. This allows for the extra ink that will be needed to make a bolder mark. Some nibs also have this ink container on top (Fig. 216). They are very useful but they must always be kept scrupulously clean after use; otherwise, they will clog up and cause a lot of trouble and waste.

This last piece of advice applies, in fact, to all types of pens. If pens are left with dried ink on them, the ink—no matter how good it is—will ultimately corrode the points and damage them.

Other types of pens are those made for writing. These pens are usually not as springy as drawing pens, but they are useful in counteracting the mark made by a heavy hand.

FIG. 209. Lithographic pen.

FIG. 213. Flat.

FIG. 210. Crow quill.

FIG. 214. Oblique.

FIG. 211. Mapping pen.

FIG. 215. Rounded.

FIG. 212. Extra fine.

FIG. 216. Ink holder on pen.

HOLDERS

Holders can be bought separately. You can therefore choose the one that will fit most comfortably in your hand. This will vary, naturally, with each individual. Lightweight holders will be more suitable than heavy ones for some people, or thick ones more comfortable than thin ones. Take some time in choosing just the right weight and thickness. Hold the pen lightly in your fingers (Fig. 217). Be careful not to grip it too hard (Fig. 218). You will always draw better with a relaxed hand. Therefore, *when choosing a pen, be relaxed.*

FIG. 217. Holding pen
correctly.

FIG. 218. Holding pen
incorrectly.

PEN LINES

A pen can do quite a number of things. For example, it always makes clean, crisp marks and for this reason is constantly used by draftsmen who work for reproduction (illustrations, diagrams, and so on). But one of the things it cannot do is to gradate tone as well as a pencil or crayon, and it can never equal the smooth transitions of a water-color wash.

Invariably you will find that pen drawings are either done solely in line (without any tone at all, see Fig. 219) or with a wash added afterward (Fig. 220). Sometimes the tones are indicated by simple "crosshatching" or by solid shapes of black to give "color" (Fig. 221).

But this does not mean that any sort of gradated tone is impossible. Too many good drawings exist which prove that it can be done. The important thing to observe is that all the tones must be built up with lines, or separate marks. The pen can only make separate marks, but if a variety of them are combined a very convincing gradation can be made.

The first exercise, then, must be concerned with what those marks are.

FIG. 219. "Portrait of
Romaine," by Margot
Hamilton Hill.

FIG. 220. Two figures.

FIG. 221. Man in a cemetery.

A pen can make an even or regular line, or a varied one (Fig. 222).

The lines can be drawn evenly side by side to make a simple tone (Fig. 223), or, by crosshatching, can make a slightly darker tone.

Crosshatching may be horizontal and vertical (Fig. 224), oblique (Fig. 225), or a combination of both (Fig. 226).

The more crosshatching, the darker the tone will be (Fig. 227).

Crosshatching, combined with dots, will give a slight gradation (Fig. 228).

Lines can be placed side by side in varying widths to give a slight gradation.

Broken lines of varying width (Fig. 229). You can combine as many kinds of lines as possible and effect a full gradation (Fig. 230).

These lines show what a pen can do, but before you tackle them, let us consider what sort of paper and ink you will need.

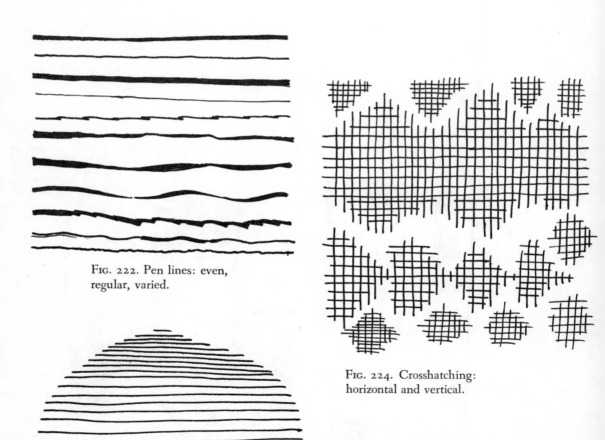

FIG. 222. Pen lines: even, regular, varied.

FIG. 224. Crosshatching: horizontal and vertical.

FIG. 223. Pen lines: simple tone.

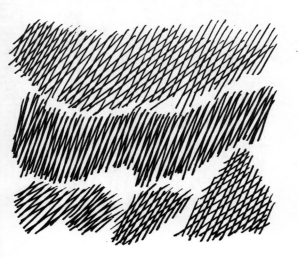

FIG. 225. Crosshatching:
oblique.

FIG. 226. Crosshatching:
combination of horizontal,
vertical, and oblique.

FIG. 227. Dark crosshatching
by repetition.

FIG. 228. Crosshatching
with dots.

FIG. 229. Broken lines of
varying widths.

FIG. 230. Full gradation.

PAPERS FOR PEN DRAWING

There is really only one kind of paper that is ideally suited to pen drawing, and that is the smooth. Whether it is a thick or thin type, a smooth paper allows the points of the pen to glide over it without interruption, and the ink flows evenly.

Any kind of rough paper will naturally impede this flow and give a broken, scratchy line. This can be useful for some kinds of drawing, but the resistance that a rough paper gives to the points of the pen can be very trying. Invariably, the points catch the paper and bend or break, or else they dig into the paper and tear it.

As a general rule, avoid rough paper.

Smooth papers come in various grades. Some are smoother than others. The really smooth ones tend to be so slippery that the pen slides over them in a skid and is almost uncontrollable. The ink also flows out much too quickly and makes a thicker line than expected.

Experiment with different papers to see how each pen behaves on them, but start with a medium-smooth—not too thick—paper.

Keep a selection of different surfaces, ranging from only slightly smooth to very smooth. For economy, cut a thin strip off each one to try out different pens. Smooth papers can sometimes be rather expensive.

INKS FOR PEN DRAWING

All inks are suitable for pen drawing except fountain-pen inks. Inks specifically made for fountain pens tend to clog drawing pens and therefore should not be used. A pen line cannot be erased as easily as a pencil line. Any unwanted lines can be either scratched out with a knife or razor blade or obliterated with white poster color.

It is less troublesome, therefore, to leave mistakes, overdraw them by adding tone (crosshatching), or to plan the drawing carefully before you begin.

All waterproof inks, including the colored inks, are very tough, and care must be taken to see that as few erasures as possible are necessary.

With the other kinds of ink, touching up with white can be very tricky. If a water-color white paint is put over an ink that is not tough the ink will mix with it and ruin the drawing.

As with pens and papers, try out all kinds of inks to see what they can do. Waterproof inks vary in consistency according to how they are made, and some inks may be more suitable for you than others. They will also affect the pens in different ways as well.

EXERCISE IN PEN LINES

On a smooth piece of paper, try out all the marks that a pen can make, as above.

Use as many different pens as possible.

Use as many different inks as possible.

Use as many grades of paper as possible.

The points to remember are these:

1. Do not force the pen to do the impossible. If it does not suit you abandon it and try another.

2. Some pens need a little time before they become worked in. To work a pen in, scribble with it.

3. If a new pen is reluctant to hold ink, it can be moistened with the tongue or dipped in water and left to dry. This should overcome the tendency for the ink to curl away from the points.

4. *Always put a new pen through the above exercise* before you draw with it. You will then be able to detect any faults. A well worked-in pen should last quite a long time. It should not let you down in the middle of a drawing.

5. You can repeat this exercise any time you wish, until you are thoroughly familiar with what a pen can do.

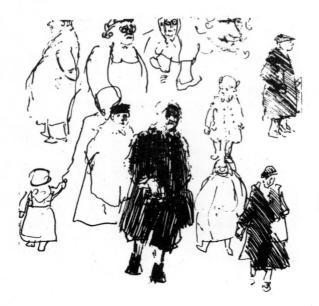

FIG. 231. Quick pen notes by
Frederick Cummins.

FIG. 232. Holborn Viaduct. (Unfinished pen drawing using toned inks.)

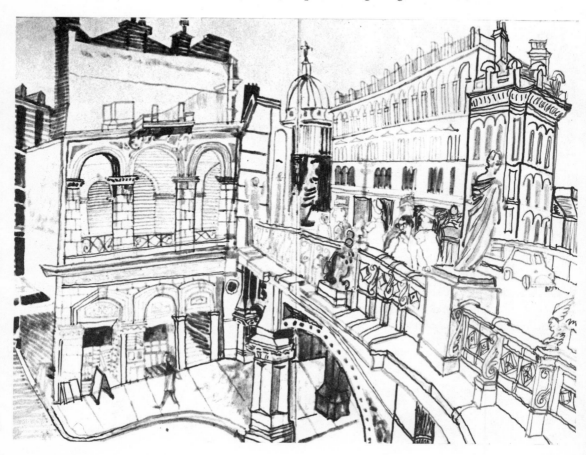

The Use of the Pen

Apart from its convenience as a good illustration medium, a pen is useful for quick drawings. The pen mark makes a convincing shorthand note when there is not a great deal of time to spare (Fig. 231).

Variety can be obtained by the simple procedure of using more than one color or tone of ink (Fig. 232). A dense black ink is harder to control than a diluted one. Drawings can be started with a light ink and overdrawn with a darker one (Fig. 233).

For outdoor drawing a fountain pen—particularly a felt pen—is most convenient. It is good for both quick sketches (Fig. 234) and elaborate ones (Fig. 235).

There are numerous fountain pens on the market for drawing, but they tend to wear out quickly and are rather limited in the type of mark they make. Ballpoint pens are also limited in the type of mark they make, but they have the advantage of making smoother gradations (Fig. 236).

Pen drawing in the main is small-scale drawing. It takes a great deal of patience to make all the separate marks needed for this kind of drawing. It would be unwise, therefore, to attempt anything too large. In fact, one of the great ad-

Fig. 233. Factory by Ian Simpson.

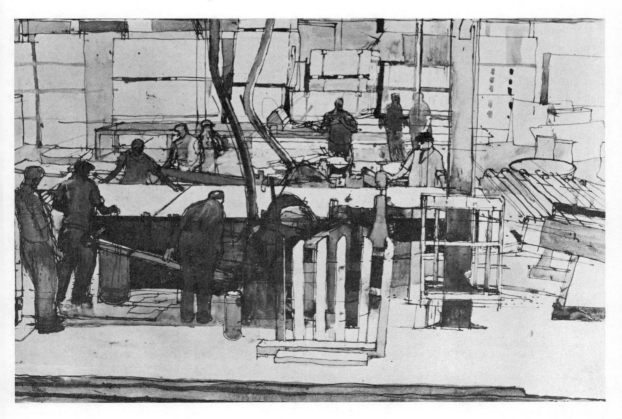

FIG. 234. Felt pen study by Ghisha Koenig.

FIG. 235. Felt pen study of Trafalgar Square.

FIG. 236. Ballpoint pen
drawing by Frederick
Cummins.

FIG. 237. Nude study in pen
by Guercino (Italian, 1591–
1666).

FIG. 238. Oxford University Press.

vantages of a pen drawing is that you can do it quite small and still achieve a rich effect (Fig. 237).

Because they are linear, pen drawings look best when the lines (and tones) are kept to a minimum. This also means that they are quicker to do. If a drawing has a great deal of crosshatching it will be necessary to spend some time on it. If you try to hurry the drawing will look very slovenly, and the result will be disappointing.

To create weight and depth without using a great deal of tone you can effectively use lines that are varied in thickness and broken (Fig. 238).

Since pen lines are easy to reproduce, good examples of pen drawing will be found in many newspapers and magazines, either as illustrations to stories and advertisements, or as supplements to editorials, and so on.

Pen drawings are best attempted after some experience with the softer media (pencil, Conté, etc.) or after some practice with a brush.

Brush Drawing

The brush is an all-purpose instrument. It can make lines like a pen (Fig. 239) or a crayon (Fig. 240). It can also make washes, that is, it can paint as well as draw. If you want to draw well in any medium it is almost imperative to get used to a brush. This is even truer if you want to master pen drawing, because

FIG. 239. Brush used like a pen.

FIG. 240. Brush used like a crayon.

FIG. 241. Myr Mawr.

a brush can do everything a pen can do (Fig. 241). But the advantages of a brush over a pen are:

The speed with which a brush can work. Pens, by their very nature, demand a slow, patient approach.

If you draw too rapidly with a pen, it is very easy to catch the points in the paper and break them. A brush has no points to break. (Unfortunately, with rough treatment, the brush hairs do wear away in time, but for the most part they are very durable and can take an enormous amount of hard treatment.)

A brush is easier to care for. One dip in a pot of water and it is clean.

Inks that are left in it to dry are easily washed out and don't corrode the hairs.

Above all, a brush—even a small one—can hold more fluid than a pen.

And one good sable brush will make as many different marks as a dozen pens.

Different kinds of paper will affect the type of mark that a brush will make, as it does with other mediums. On smooth paper, brush lines will be crisp and clear. On rough, the line will be jagged and broken (more like that of a crayon). However, these jagged effects can also be obtained on a smooth paper by using a dry brush, that is, a brush with very little ink on it. The result is very attractive and useful. But while it is advisable to avoid rough papers when using a pen (especially a very fine one), even a fine brush can draw on them with the greatest ease.

Types of Brushes

The various kinds of brushes that are available have already been mentioned in Chapter 2. Here we will deal with sizes and shapes.

The most commonly used are the round brushes; the others are flat, long, and square (Fig. 242).

The flat, long, and square brushes are restricted in the type of marks they make.

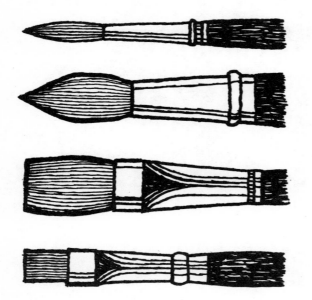

Fig. 242. Round, flat, long, and square brushes.

Flat brushes are useful for washes and filling in large areas; long brushes, for thin lines only (these are often used for lettering by sign writers, and for oil painting, when thin lines are needed).

Square brushes are limited to a square mark, which can be useful for certain types of drawing.

So in the main, it would be better to start with round brushes.

Round Brushes. These can be used to make almost any kind of mark and for washes. When choosing your round brushes, select a variety of sizes. Generally they are graded by numbers. The smallest numbers (oo, o, 1, 2, 3, 4) refer to the smaller brushes; the larger numbers (5, 6, 7, 8, etc.), to the larger ones. Nos. 3, 5, and 8 may be a good combination for starting a collection.

Choose only sable brushes. Sables are the strongest and the most flexible. If they are well cared for they will last almost indefinitely, although the points of some of the smaller ones (oo, o, 1, and 2) tend to wear out rather quickly, even

when they are carefully treated. This is no reflection on their quality, which is often of the highest; it is simply the nature of these brushes.

Most brushes are made with nonrusting ferrules and have polished handles. They are easy to keep clean and are delightful to hold.

When choosing a brush, remember that (like a pen) it is the point that is important. A good point will make fine, flexible lines. To be sure that your brush has a firm point and does not split (a common fault in a bad brush), dip it into a pot of water and flick the water out of it. If it is a good brush the hairs will come to a point immediately. Most stores that sell brushes keep a pot of water available for this purpose—if, when buying, you don't find one, insist on it. Sometimes, when a brush is put on display a slight amount of gum is added to it to bring it to a point. This is deceptive. When placed in water or ink the gum dissolves and the point never returns. A good sable should always make a point after being dipped in water and flicked dry. If it does not do this it should be rejected.

Cheaper brushes, made of less flexible hair, often lose their points very quickly (if they ever begin with one). They may work very well for washes, but for lines they are worse than useless.

When a brush does finally wear out, it should not be thrown away. It can be used for all sorts of things, especially for textural effects. It can also be used for varnishing or mixing up diluted washes and thus save wear and tear on newer brushes.

Most new brushes work quite well the first time they are used, but others may need a little working in. Give them a chance to adjust to your touch before rejecting them. A good method of gently working a new brush in (and incidentally keeping its point in trim) is to roll it lightly in some white paint diluted with water, as if you were mixing up the white paint.

When brushes are put away, the points must be protected first and the hairs second.

To protect the point, a cylinder with a lid or a long box will do; for the hairs, some moth-preventive crystals should be added to the box.

Making Washes. A brush can make all the marks that a pen can and should be experimented with in much the same way (as in the pen-drawing exercise), except that it will be unnecessary to do a great deal of crosshatching because a brush can make gradated washes.

It is not difficult to lay a wash, but to do this—as with most techniques—a little practice is needed. These are the points to watch:

1. Have plenty of clean water at hand for making and diluting washes, and also to keep your brush clean.

2. Mix a good supply of your wash colors (water color, diluted inks, and such). It is hazardous to begin laying in a wash and then to run out of color. Successful washes depend on speed and deftness of touch.

3. Make sure that the paper is not greasy. If the paper can stand it dampen the surface slightly all over. If the paper is thin, stretch the paper first, otherwise the paper will wrinkle when the wash dries. Stretching is explained in the next section.

4. Once a wash has been put down, leave it alone. Whatever happens, do not interfere with it once the brush has made its mark, or it will be ruined. The secret of a good wash is to let it find its own level on the paper. (See Fig. 243.)

5. At first, tint your drawing with as little wash as possible. In any case, it is better to confine the amount of wash to the barest minimum, otherwise it will swamp your drawing.

6. Don't attempt to stretch paper with a drawing already on it. This will distort the drawing. If you wish to use stretched paper for tinting stretch the paper first, then do your drawing and tint it with washes afterward.

7. In a sketchbook, washes should be kept to a minimum because of wrinkling and because they are more difficult to do outdoors.

FIG. 243. Brush drawing with wash by Rembrandt (British Museum).

Gradating a Wash. When gradating a wash, your drawing board must be tilted at an angle so that the wash flows downward.

If the wash is to be properly gradated, the heaviest tone must be flooded into a slightly damp surface. As it spreads it should be controlled by a clean brush that will act as a form of blotter. The brush should be just moist enough so that it will pick up excess wash neatly.

If you find that you cannot control the wash, don't worry too much about it. Even the best artists can make a mess of a wash. Turner, one of the world's greatest water colorists, repeatedly made bad washes until in desperation he put them under a faucet. This, he discovered, improved his drawings, instead of ruining them. It gave a much more subtle gradation. He often remarked that his best friend was the faucet. We can also follow his example and when a wash goes sour on us, put it under a tap and try again. But don't be too brutal with it. Only a gentle scrubbing will be needed, otherwise you will go through the already weakened damp paper. This won't, of course, happen with thick papers. They can take any amount of scrubbing.

In doing a wash, the size of your brush is important. If you are going to cover a large area, it is annoying to do so with a small brush. Use a large brush. It holds more color, for one thing, and also eliminates frequent dipping. It covers the area rapidly—and *speed is essential* for laying a wash.

Make sure that the wash has no undissolved fragments of color in it. If they get onto the paper they will make a blemish which will be hard to remove without destroying the transparency of the wash.

To ensure that the wash will float evenly without blemishes, try it out on a separate piece of paper first.

Washes are transparent. If you are going to do a number of them in one drawing, the best rule to follow is: *Begin with the light tones, then add the darker tones, and end with the darkest tones of all.*

Once a dark tone is laid, it can only be removed by putting the paper under the tap. This may not be possible without sacrificing good passages you want to keep.

Pen lines can also be added to a wash drawing for variety. Carbon and Conté can be added, as well. If you do this, however, the drawing must be fixed. If, on the other hand, the wash is put over a carbon or Conté drawing, the wash will do all the fixing necessary.

STRETCHING PAPER

Only stretch paper when you want to do a large wash. When a wash dries it tends to wrinkle or cockle the paper. The more wash that is used, the more cockling there will be. With some of the thicker, hand-made papers this does not always happen. In fact, the thicker the paper, the less likelihood there will be of

any sort of change in its surface. On the other hand, if you have any doubt about what the paper will do, it is safer to stretch it.

It is easy to stretch paper. First, dampen it on both sides; just barely wet, not dripping. Any superfluous water should be wiped or shaken off before stretching. Then place the paper on a clean board and stick it down at the edges with masking tape. (See Fig. 244.)

FIG. 244. Stretched paper.

You will note that the tape overlaps at the corners of the paper. Half of the strip should be on the board, half on the paper.

Allow the paper to *dry naturally*. Any form of artificial heat will tend to make the paper dry too rapidly, and there is a great danger that it may split.

While drying out, the paper may take on a very wrinkled look. If it has been properly laid down and firmly stuck it will flatten while drying.

When the paper is thoroughly dry, it can take as much wash as required. It will, of course, wrinkle again when wet, but after drying out will flatten again.

After completing your drawing, the paper must be gently taken off your drawing board and trimmed. Any tape that is left on the board should be immediately soaked off with water.

If the paper is wrinkled when it dries out after stretching, it can be flattened by resoaking while it is still fixed to the board. If this fails, the best method is to take the paper off completely and stretch it again.

Make sure you fix the paper to a solid board (that is, a drawing board). Cardboard, for instance, will bend with the tension of the drying paper and the paper will remain bent when fully dry.

CHAPTER 9

COMPOSITION

Drawing is the basis of all the visual arts. Before beginning any major imaginative work, an artist usually sketches his ideas for it. These ideas come from his imagination. But the imagination cannot feed entirely on itself; it is difficult to create something from nothing. Therefore, the imagination must depend on outside stimuli in order to function well. For the artist these experiences come from observing and drawing life itself.

The problem is, how do we deal with these ideas when they arrive? Ideas are like fresh eggs—they won't keep indefinitely. Unless something is done about them quickly, they spoil.

The answer is *composition*.

The elements that are collectively called "composition" will help give coherence to any ideas that evolve from:

1. Sketchbook notes, incomplete scribbles, fragments, and such.
2. Finished drawings done on the spot.
3. Memory.

In the first instance, scraps of information, which in themselves are quite useless, may be the start of an idea for a picture. Combining these with ideas from other drawings plus things you remember, you can weld a convincing whole by using the principles of composition.

In the second instance, the drawing is virtually completed, yet you may have further ideas about it. You may wish to alter it by adding or taking out something; to enlarge it; to adapt it to another medium (etching, lithography, etc.); to combine it with another drawing; or to use it as the basis for a decoration (for a pot, a wall, or a book).

The last instance—relying on your memory—is the hardest to do. Memory is so elusive. The elements of composition will reinforce your remembered ideas and give them expression.

The Elements of Composition

1. Balance (symmetry and asymmetry).
2. Proportion (how much to how little).
3. Selection (what to put in, what to leave out).
4. Emphasis (focal points, signposts).
5. Variety (avoidance of monotony).
6. Rhythm (movement in line, pattern; repeated emphasis).
7. Arrangement (putting the elements together so that they cohere).

The elements of composition derive from nature, but because in nature they are more widely dispersed, they are easily overlooked when drawing directly from natural sources. A study of composition principles will help your study of nature and improve your direct drawing techniques accordingly.

It must be noted that to help you recognize and deal with these elements, they have been isolated from each other. This is, of course, completely artificial. Each element overlaps and integrates so closely with the others that it is hard to say where one begins and the other ends. So long as you understand this, you will have little difficulty in grasping what these elements do.

Balance. Most compositions are set within a rectangle. How we divide up that rectangle so that it will be visually interesting must concern us first.

The divisions must balance, but this does not mean they must be equal (Fig. 245). Equal divisions (symmetry) are monotonous visually. Unequal divisions (asymmetry) are much more exciting (Fig. 246).

In placing objects, the same rule applies. If we have one main object and place it centrally in the rectangle (Fig. 247), it is much less interesting visually than if we place it a little to one side and balance it with something smaller (Fig. 248). If several objects of similar size are dispersed equally in the rectangle, the result is monotonous (Fig. 249), but more interesting if grouped asymmetrically (Fig. 250).

Fig. 245. Composition: equal
spacing.

Fig. 246. Composition:
unequal spacing.

FIG. 247. Composition: central placing.

FIG. 248. Composition: balanced by something smaller.

FIG. 249. Composition: equal placing.

FIG. 250. Composition: asymmetrical grouping.

We must consider the balance of shapes not only across the rectangle but also up and down it. If the weight is stressed too heavily above the middle of the paper it will overbalance the top (Fig. 251). This can be counterbalanced by a stronger weight below (Fig. 252). Or the weight can be entirely distributed below, as in a great many pictorial compositions (Fig. 253).

This triangular figure can be seen in numerous works produced during the Italian Renaissance (Fig. 254).

FIG. 251. Overbalance from above.

FIG. 252. Balance from below.

FIG. 254. Triangular balance in a drawing by Leonardo da Vinci.

FIG. 253. Triangular balance.

Proportion. Proportion is integrally bound up with balance. The fine distinction between them may be summed up as follows:

Balance deals with placing and division.

Proportion deals with quantity.

"How much to how little" will apply to tone as well as shape. The delicate relationship of black to white can be destroyed if any tone is used disproportionately (Fig. 255). The balance can be restored by the use of gray (Fig. 256), more white (Fig. 257), or more black (Fig. 258).

Even the symmetrical placing of divisions can be excused if the proportions are of the right tonal quantities (Fig. 259).

FIG. 255. Tone disproportionately used.

FIG. 256. Balance restored by use of gray.

Fig. 257. Balance restored by
using more white.

Fig. 258. Balance restored by
using more black.

Fig. 259. Varied tone in
symmetrical divisions.

Selection. What you put in and leave out will be determined both by the
proportion and balance of your subject. When the original source of your idea
comes from drawings done in front of the object (or subject), you may find that
you have collected far too much information. The result is confusing. This is
neither a bad nor an uncommon thing. When confronted with nature, you are
always better off if you have too much of a good thing; you can sort it out after-
ward to give it clarity.

Usually, confusion is caused when two different textures adjoin (Fig. 260).
For the sake of legibility, one of them should be eliminated.

On the other hand, if each part of the original drawing has been overworked
with the same intensity, none of the parts has any intensity at all! (See Fig.
261.) Therefore, some selection is needed to ascertain which is more important
(Fig. 262).

FIG. 260. Two adjoining textures.

FIG. 261. Overworked drawing.

FIG. 262. Selection to restore balance.

FIG. 263. Woodcut by Eric
Ravillious.

FIG. 264. Directing lines of
Fig. 263.

FIG. 265. Woodcut by Eric
Ravillious.

FIG. 266. Dominating object
directing the eye in Fig. 265.

In time, however, you will be able to do much of this selection on the spot, so
that a large part of the work will have been done beforehand. But as a general
rule, *it is better to collect too much than too little, especially if you find that your
memory is not able to supply anything left out.* In succeeding sketches you can
always eliminate.

Selection depends entirely on the individual concerned. The aim is to present your ideas as clearly and as interestingly as possible.

If you eliminate too much the result will be too thin and something will have to be put back. One of the best examples of good selection in action is a series of drawings etched by Picasso on copper. The first drawing is a straightforward study of a bull that is overdrawn, but beautifully seen. In the next drawing, he has eliminated some of the surface textures (hair, lights and darks, etc.) to give a more unified look. But he was still uncertain of what he had left, and in the succeeding drawings he eliminated more and more, until in the final drawing all that is left are a few exquisitely drawn lines. This drawing is as remote from the first drawing as it could possibly be, but nevertheless it is still "bull-like," even though completely transformed. It is the best example available of how a great artist works. Too often, artists destroy the preparatory steps that go to make up a final work. But careful study of their existing drawings could reveal something about how they worked if you look at them in this way.

The selection of those parts that can make a better whole will depend a great deal on your eye, your notes, and your imagination. If, for some reason or other, you cannot make up your mind what to do, rely on this simple observation:

<div style="text-align:center">

If in doubt
Leave it out!

</div>

Emphasis. Every drawing has some part that dominates everything else. Usually it is so dominating that it draws attention away from the rest. You must work carefully to ensure that what *does* dominate works the way you want it to work. The point you wish to make significant may be small or in the background. In this case, the emphasis has to be shifted from dominating shapes

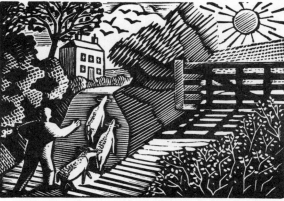

Fig. 267. Framing the focal point.

Fig. 268. Woodcut by Eric Ravillious.

and tones, so that there will be no doubt where the interest lies (Fig. 263). This can be done by:

 1. The use of directing lines (Fig. 264).

 2. Using the dominating object to point out the part toward which the eye is to be directed (Figs. 265, 266).

 3. Using the dominating objects to frame the part to be noticed (Fig. 267).

 4. Rearranging the dominating objects.

 5. Suppressing them in tone.

These same effects can be used, either together or separately, if there are two focal points (Fig. 268). It is not unusual to have more than one center of interest. As long as the eye can flow easily between them (that is, if one is not more dominant than the other), this is perfectly justified (Fig. 269).

Fig. 269. Two focal points in Fig. 268.

Variety. It is fairly obvious that the principles of composition are aimed at avoiding monotony. Monotony not only produces boredom but can be positively painful (to the eyes and the emotions, as well). To achieve maximum variety, these factors should be avoided:

 1. Too many horizontal or vertical lines (Fig. 270). These repeat the lines of the frame, and if overdone, not only flatten the drawing but limit the idea as well. Vary these lines with curves (Fig. 271) or angles (Fig. 272).

 2. Too many small shapes. This effect can be irritating to the eye. Contrast with large shapes (Fig. 273).

 3. Too many square shapes (Fig. 274). Contrast with curves, oblong, or triangular shapes (Fig. 275).

 4. Too much of one tone (Fig. 276).

 5. Too little tone (Fig. 277).

Fig. 270. Too many horizontal
and vertical lines.

Fig. 271. Horizontal and
vertical lines varied with
curves.

Fig. 272. Horizontal and
vertical lines varied with
angles.

Fig. 273. Small shapes varied
with large shapes.

Fig. 274. Too many square
shapes.

Fig. 275. Square shapes
varied with curved, oblong,
and triangular shapes.

FIG. 276. Too much of one
tone.

FIG. 277. Too little tone.

FIG. 278. Patterns.

FIG. 279. Lines.

FIG. 280. Shapes.

Rhythm. The compelling power of a regularly repeated motif is well known in music. We also know the importance of the simple, regular percussion rhythms in jazz. If rhythm is used in the musical sense as an underlying factor to enhance—and not to dominate—a drawing, monotony will be avoided. The rhythm may be used in the form of:

1. Patterns (Fig. 278).
2. Lines (Fig. 279).
3. Shapes (Fig. 280).

Arrangement. The ultimate aim of composition is to take all these diverse elements and combine them into a satisfying whole. In this we are helped by any drawings we have done. But there are two points to consider:

1. More "designing" is needed when your drawings consist of scribbles and notes. That is to say, you will depend more on the elements of composition to fill the gaps. Therefore, if these elements are put together without any reference to natural forms, the result will be an "abstract" design (Fig. 281). You may either put these elements together in an abstract form first and then superimpose the imagery afterward (Fig. 282), or do all of these things together.

2. On the other hand, if your information is fairly comprehensive, only a few of the above principles will be needed to bring out any ideas intended.

No matter which of the above approaches you take, you will need to do a certain amount of correction, modification, and alteration. Changes should always be tried out on a copy, never on the original drawing. To make this less irksome, the use of tracing or detail paper is recommended.

In transferring your alterations from one page to another by tracings, you not only save time but you preserve the freshness of your ideas, and you also preserve

FIG. 281. Abstract design.

Fig. 282. Trees by Allin Braund.

the steps by which you arrived at them. If at the end of a series of changes you are still dissatisfied, it is refreshing to turn back to an earlier stage to see where the idea went wrong and try out another series of tracings from that point.

When your drawing is in a sketchbook, do not tear it out. Instead, trace it in clear, simple lines. Then, with the original drawing in front of you as a guide, you can make what alterations you please. (Do not, on any account, touch an original drawing.) Your drawings done on the spot are only of value when they are left alone.

ENLARGING A DRAWING

When enlarging a drawing, tracing paper is again invaluable. These points should be noted.

1. Keep the tracing clear of tone.
2. Use crisp, clean lines.
3. Be sure that the tracing does not rub out. Use fixative or a pen.

When the drawing has been traced and altered to your satisfaction, you can enlarge it by the process of squaring up, done with squares or rectangles.

The principle of enlarging by squaring up consists of:

1. Marking off your drawing with a series of equal squares or rectangles.

2. Marking off on a separate sheet of paper an identical number of squares or rectangles that are uniformly bigger (Fig. 283). If you use squares, for example, and your drawing measures 3 by 4 inches, you will have twelve squares of 1 inch each. The drawing can be enlarged to any size as long as it has twelve squares arranged in the same way.

If you cannot measure your drawing in inch squares, you can mark out your drawing with rectangles by dividing them up on a diagonal (Fig. 284). The enlargement, however, must be in proportion to the original. You cannot enlarge a 3- by 4-inch drawing to a size of 4 by 4 feet. The correct proportion would be 3 by 4 feet.

To be sure that your enlargement is in proportion, the diagonal should go accurately through the corner of the small drawing to the allotted corner of the enlargement (Fig. 285).

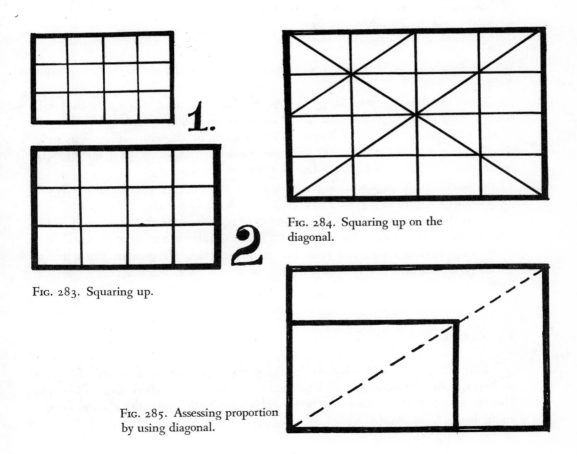

Fig. 283. Squaring up.

Fig. 284. Squaring up on the diagonal.

Fig. 285. Assessing proportion by using diagonal.

Always draw in line.

Avoid tone, if possible. Tone can lead to confusion.

The more squares you use, the more accurate the enlargement will be.

Always number your squares to avoid drawing the wrong square by mistake. Number at the top, bottom, and sides (Fig. 286). Another alternative, to avoid confusion, is to letter the top and bottom and number the sides.

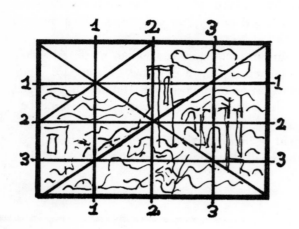

FIG. 286. Numbering squares.

The squares may be done in a different color from the drawing to prevent a mix-up.

In the enlarged version keep the squares light in tone, otherwise they will interfere with the final drawing. If they do interfere, don't erase them—this will lead to messiness. Try to obliterate them instead by drawing over them more boldly, or use white paint with your other media. White will not only extend your tonal range, but is a good obliterator of unwanted lines.

Being able to enlarge drawings by squaring up is a very useful ability. It can be used in all sorts of ways. However it does demand patience. If you find that the process is a trying one, limit the number of squares. It is amazing how few are really needed. But unless you have a good eye, it is safer to use more squares.

If, on the other hand, you find that an inaccurate enlargement looks just as good, go ahead and use it. You can always do another, more accurate, version later.

CONCLUSION

Many years ago, in an effort to disparage the experiments of artists who were to become the founders of modern art, a famous critic called them (Georges Braque in particular) "mere decorators" because their work dealt with fundamentals.

Another famous art critic, Roger Fry, defended the modern movement and was largely instrumental in clearing the way for wider appreciation of it. Yet he attacked artists whose work was different from the moderns. He dismissed Pieter Bruegel as a mere "illustrator" because he told a story.

Both critics were wrong in that each dismissed one of the two vital ingredients that go into all works of art, for the sake of emphasizing the other.

If story, idea, or illustrative content is stressed in some works of art, this does not mean that the formal elements are absent. They are usually not neglected, but are probably hidden underneath.

If an artist has decided to stress only the formal elements, naturally the result is far more decorative.

It is also true that when both these qualities are weak or even absent in art, the critic will, in an effort to be fair, exclaim: "Yes, but this work, though without formal or visual content, is expressive of the soul, spirit, id, psyche, philosophical view" (choose your own term—they are all interchangeable), which is meaningless.

Composition is the structure on which works of art are built. If you are attracted to design or decoration in which all reference to appearances is eliminated or refined, composition is absolutely necessary.

If you can only express ideas by reference to nature composition will help you to understand nature better.

The ideal solution to the dichotomy that runs through contemporary art (abstract versus visual appearance) would be to integrate them both.

It has been done before. You have only to study drawings and paintings of the past, and you can see that works of art have been both decorative (abstract) and visual (illustrative).

This is a simple solution to the enigma of modern art. If, in nature, a common denominator can be found—that is, shape—then in imaginative art it will be found in the elements of composition.

THE CARE AND EXHIBITION OF DRAWINGS

Drawings should always be kept at least three months for selection and review. The bulk of the work done in that time will be sufficient to give a good idea of development.

A few of the best pieces can be retained for another three months and compared with the new work that follows.

SELECTION AND REVIEW

All your drawings, both finished and unfinished, should be pinned up consecutively across the wall. If this is not possible, they may be laid on the floor.

If the output of three months is too great to hang all at once, do it in sections.

As a general guide, reviewing can be done after twenty-five or thirty drawings have been collected. If your output after three months has been small leave your drawings up longer than three months until that number has been reached.

The drawings must be viewed as far away as possible.

Selection can be made with or without assistance. But do the job quickly. If you linger too long, debating the good or bad points of one drawing, confusion will set in and cloud your wits. Make your choice for good or bad, and stick by it. This will aid your critical faculties and mold a strong point of view. No doubt you will change your opinion the next time you see your drawings. Allow for this as a sign that your judgment is developing as well.

If you choose to keep *all* your drawings, do so for another three months, or until you have another twenty-five drawings, and review them again.

Ultimately, a certain amount of weeding out will take place quite naturally. You will grow more confident the more you do it.

The drawings finally retained after a year's selection can be mounted on cardboard for safekeeping.

It may occur to you that some drawings would look better cut down to a smaller size or that a fragment could be rescued by being cut out. These "cropped" drawings can also be mounted or stuck into a sketchbook.

MOUNTING

Mounted drawings are less likely to be damaged. They also look better. They can be mounted singly or in groups.

They can be fixed either directly on the card, or a rectangular hole can be cut out like a frame and the drawing stuck on from behind (see "Cut Mounts" later in this chapter).

As a rule, if the drawing is large or powerful, it is better mounted alone.

But if the drawings are small, or belong to a series, or are enhanced by being together, they can be mounted as a group.

In all cases, the drawings must be arranged so that the card's borders are proportional to the drawings (see below).

Mounting Card. Mounting card can be bought either thick, thin, surfaced, unsurfaced, white (or off white), or colored (or tinted).

The best card will be thick, surfaced, and white (or off white). This type will wear better and look better, but it is generally more expensive. Tinted cards are often muddy and rarely add anything to a drawing. Brightly colored cards may look attractive, but often kill a drawing.

Unsurfaced cards are unreliable. They lack finish and make drawings look scruffy.

If a white card is used make sure that the drawings are well fixed beforehand, otherwise superfluous media will get on your hands and finally onto the card. Mounts must look neat and clean if they are to be of value.

Arrangement. Arrange the drawings on the card *before* you stick them down to see how they look.

For single drawings, the proportions best suited are:
1. Bottom greater than top (Fig. 287).
2. Sides the same as each other, but slightly less than the top (Fig. 288).
3. Sides may also be the same width as the top (Fig. 289).

For more than one drawing, be guided by the number and size:
1. Avoid crowding drawings together (Fig. 290).
2. Leave plenty of border area between drawings (Fig. 291).
3. Vary the drawing sizes to give interest (Fig. 292).
4. Vary the arrangement, according to the tone (Fig. 293).
5. Avoid monotony.

FIG. 287. Bottom greater than the top.

FIG. 288. Sides same but less than the top.

FIG. 289. Sides and top same width.

FIG. 290. Avoid crowding.

FIG. 291. Leaving plenty of border.

FIG. 292. Varying sizes.

FIG. 293. Varying tone of
drawings.

Pasting. When the drawings are arranged to your satisfaction, note where they are to go on the card with a tiny pencil mark at each corner. See that the pencil marks are perfectly square.

To avoid dirty marks and to allow for any shifting while you stick the drawing into place, rubber cement is recommended. Unlike glue or paste, rubber cement is easily rolled off without staining.

Cut Mounts. Cut mounts are more attractive, but take more time and care to do. This is the procedure:

1. Mark out where the drawings are going *on the reverse side* of the card.
2. The rectangular hole must be smaller in size than the drawing (¼-inch minimum all around).
3. Cutting is also done on the reverse side.
4. Measure the rectangle accurately before cutting.
5. Use a sharp knife for cutting and a steel ruler for guiding.
6. Be careful at the corners.
7. For thick card, more patience and pressure will be needed.
8. Attach drawings at the back with rubber cement first to ensure accuracy of placing. Complete with tape.

Once you have cut out your rectangle, you cannot put it back. If the hole is lopsided, it will ruin the mount. If you have removed too much card, your drawing will fall through. So take care with your measurements.

As a final warning: *Don't cut your mounts on a drawing board*. Keep a spare sheet of thick, cheap card especially for this purpose. Also, have a damp cloth available to wipe your hands on from time to time. Perspiration makes marks that are hard to remove.

Mount cutting, like framing, demands quite a bit of skill. If you don't feel up to it let a professional do the job for you.

FRAMING

A mount keeps work safe for infrequent viewing. A frame means you are going to hang it and look at it permanently.

It doesn't matter how many drawings you mount. They can be discarded if and when necessary. But framing is another matter. You will not want to frame everything you draw. Some drawings may not be the sort that frame well, anyway. (Some drawings only look well mounted. They are best seen when held in the hand. When hung, they fade into obscurity.)

Also, framing is expensive in comparison with mounting.

Successful framing must be done by a professional frame maker, for these reasons: A good frame must be strong, but not heavy; it must be glazed to protect the drawing; the mounts must be expertly cut and colored.

For an oil painting, the larger the frame, the thicker the wood; but for a drawing, however large, the frame must be elegant. So it has to be very well made. The mount can be very thick, with a nice deep bevel, or it may be colored and built up in layers, or decorated (Fig. 294).

A generous mount and a thin frame allow the drawing to glow.

A small mount and a clumsy frame will dim the impact (Fig. 295).

A good frame maker knows all this, so you can trust him completely. You may discuss the color of the frame and make suggestions. After all, you know

FIG. 294. Built-up decorated frame.

FIG. 295. Poorly mounted picture.

where it is going to be hung and he doesn't. After that, leave the rest entirely in his hands.

Bear in mind, however, that a drawing will ·be a lot bigger when framed. You must add to it the extra width of mount and frame (which can be quite a lot, as much as 6 inches all around, with 8 inches on the bottom for large drawings).

GLAZING

The second point—glazing for protection—is an important one.

Drawings are much more fragile than oil paintings; paper is less robust than canvas. You can protect oil paint with varnish and keep the canvas rigid. But paper and crayon easily collect dust and moisture. The paper wrinkles, the drawing smudges. A varnished oil painting can be dusted or gently cleaned with soap and water. This would ruin a drawing. Therefore, if a drawing is to be protected from these hazards, it must be glazed—and glazed well.

Cutting glass is no easy job for a beginner; setting glass into a frame to fit tightly demands care. Backing it properly to ensure that it is dustproof and moisture-proof requires knowledge and skill.

SELECTING A DRAWING FOR FRAMING

You can leave the frame to the frame maker with confidence, but you will have to select the drawing for it yourself.

Here you must use your own judgment, but as an aid, repeat the selection method used for mounting, only in this case, look at each drawing separately, keeping the others out of sight.

Do not make your choice from anything unmounted. The mounting around a work helps you to make up your mind. Unmounted work is difficult to imagine in a frame. Mounted drawings are halfway there already.

It is exciting to frame your own work. It is also exciting to frame the work of others. Old and new masters, originals and reproductions can also be framed.

Again, how are you going to make your choice among the many works done by other people?

Let's have a look and see what there is.

A VERY BRIEF HISTORY
OF DRAWING

Famous Artists and Their Drawings

Throughout the history of art some periods have produced a great many drawings which are considered masterpieces, and other periods none at all. Even in the productive periods some artists have drawn a great deal, while others seem to have done very little drawing, but worked in other phases of art such as sculpture, carving, or oil painting.

There is no doubt whatever that artists throughout every period drew and drew copiously. Well, where are the drawings to prove it?

To take a case in point: two contemporaries, Degas and Pissarro, who lived and worked in France, were both considered during their time to be advanced or modern. Yet while Degas left hundreds of drawings behind, Pissarro left so few that it is difficult to find any now.

They were both fine painters who contributed much to the advancement of art. The work of both is equally pleasurable to look at.

Nevertheless, Pissarro, a gentle, honest man, must have done just as many drawings as Degas, because in the published letters to his son Lucien (who was studying painting in England), he writes over and over again, "draw, always draw . . ." and instructs him to "do so at least once a day. . . ."

It is hardly likely that Pissarro, who was the soul of integrity, would give such advice and not take it himself.

Then where are his drawings?

The answer, I fear, is that they are lost. It is so easy to lose a drawing. Somehow, because it is done quickly, it is as quickly destroyed. Perhaps the artist tears it up after he has finished with it or perhaps it is thrown away after his death—we don't really know. What we do know is that it is a lot harder to lose or destroy carvings and castings, canvas and wood panels.

Drawings are fragile. Paper is easily torn or burned. Yet paper wears far better

than canvas or wood. In time, canvas rots, wood splits and gets worms, but good paper will last.

Nevertheless, the drawings that have come down to us through history have been uneven in quantity, though not—it must be added—in quality.

This will, I hope, explain why constant reference is made to certain artists. It is not that their fellow artists were inferior, but because so little of their work is left that we cannot make judgments about it.

With these thoughts in mind, the following brief history was compiled. It does not pretend to be a complete list of all the draftsmen available, but it is given as a guide.

THE ANCIENT WORLD

The earliest forms of art consisted of paintings on cave walls, scratchings (graffiti) on walls and tools, and carvings.

The paintings are, in effect, drawings, since little color is used in them, and sometimes none at all. The scratchings, too, are a form of drawing.

The paintings on the walls of Egyptian tombs, on coffins and such are much the same. They are basically colored drawings, executed in water color, and can be studied as drawings, since the approach is mainly linear.

THE GREEKS AND THE ROMANS

The Greeks were prolific artists. Through their architecture, sculpture, and pottery (to name only three) they have dominated Western thought and culture. Yet the only drawings to survive are those that decorate their pottery. These are, of course, nothing less than magnificent. Figures, animals, landscapes surround each pot with delicate, lively, linear forms. In the early pots, the figures are highly stylized; that is, as in the Egyptian wall paintings, the conventions of "looking always in profile," stiff movements, and such, prevail.

These vase drawings are well worth studying. In the later pottery the figures are more graceful, though the emphasis is on the decorative. Strong blacks and whites prevail over tonal gradations.

The Romans, on the other hand, seem to have taken up only what the Greeks discarded. Aesthetically, the Romans contributed little to what the Greeks had already discovered. The Romans were more concerned with engineering construction; they didn't bother much with art. If they wanted to decorate their buildings (which were structurally far in advance of the Greek buildings, because of their discovery of concrete), they merely copied or added existing Greek work.

Nevertheless, there are some interesting paintings at Pompeii and in the

Naples National Museum, which, because of the method used (water color on plaster), have a strong linear quality akin to drawing.

No other form of drawing survives.

THE MIDDLE AGES

It was not until the rise of Christianity that drawing came into its own. From 600 A.D. onward, drawings were used to decorate manuscripts, religious texts, and the Bible itself. By the eleventh century, all manuscripts were decorated with drawing. The full flower was reached in the Gothic period.

After that time, drawing in many forms—with pen, brush, color; on paper, vellum, and walls; engraved or cut into wood for printing—became a basic means of expression. It inspired the fifteenth-century German and Flemish wood carvings; the French stained glass, and the Italian mosaics that flourished everywhere. When the Renaissance began to dawn drawing was so much a part of the cultural scene that the transition to the more sophisticated ideas of the Renaissance was easy. Drawing became the important basis of all the other arts.

Now we have drawings of that time from Italy, France, Holland, and Flanders —not as finished products in themselves, but as working drawings for other projects.

THE RENAISSANCE

The Italian Renaissance, 1300–1700. Giotto and Masaccio were the keystones of splendor to come, but none of their drawings has survived. Instead we have drawings by:

> Antonio Pisano ("Il Pisanello")
> Vittore Carpaccio
> Cosimo Tura
> Andrea Mantegna
> Sandro Botticelli
> Antonio Pollaiuolo
> Ghirlandajo (Pseudonym of Domenico di Tommaso Bigordi)
> Gentile and Giovanni Bellini
> Luca Signorelli
> Pietro Vannucci ("Il Perugino")
> Leonardo da Vinci
> Raphael
> Michelangelo
> Titian

Jacopo Robusti ("Il Tintoretto")
Jacopo da Pontormo
Paolo Veronese
Giovanni Battista Tiepolo
Antonio Canaletto

Flanders, 1400–1600.

Jan van Eyck
Rogier van der Weyden
Hugo van der Goes
Gerard David
Hans Memling
Hieronymus Bosch
Pieter Bruegel (the Elder)
Peter Paul Rubens

Germany, 1400–1600.

Albrecht Dürer
Matthias Grünewald
Hans Holbein

Holland, 1500–1700.

Rembrandt

France, 1500–1700.

François Clouet
Antoine Watteau
Jean Honoré Fragonard

Spain, 1700–1800.

Goya

AFTER THE RENAISSANCE

The great movement known as the European Renaissance had finally petered out by 1750. It could be said to have run its course by the time of the Industrial and French revolutions.

From this point we can date the beginning of the modern era in art.

In England, two painters who were aware of the new spirit were John Constable and Joseph Mallord William Turner, who lived and worked about 1800.

Both were fine water colorists and drew copiously.

Both were to influence European painting tremendously, by being perhaps the first painters to work directly from nature. Before their time it was common practice to "cook up" landscapes in the studio. Sometimes direct drawings were used, but they were so transformed by the time the artist had finished with them that they bore little or no relation to nature.

When Constable and Turner looked nature in the eye and noted the light
and the weather, their work became lighter, fresher, and much more colorful.
Before their work, landscapes had a "brown" look that was thought to be classi-
cal in conception. Nature seemed stewed in gravy. Constable and Turner re-
moved the gravy. The modern landscape was born.

England, 1800–1960. Other notable English draftsmen include:

Thomas Rowlandson
Thomas Bewick
Samuel Palmer
Charles Keene
Walter Sickert
John Minton
Anthony Gross

France, 1800–1900. After the Revolution, French art went through a classi-
cal revival. Women wore clothes modeled on Greek styles and reclined on copies
of Greek furniture. Artists drew pictures of Greek statues and bas-reliefs in the
mistaken idea that by doing so they too would be able to create masterpieces.

The practice of copying ancient art spread throughout Europe during the
nineteenth century and became a part of all art training. Before a student was
allowed to touch a brush or pen, he had to laboriously copy any one of a num-
ber of famous Greek sculptures. To do this, he used black chalk powder and a
stump, a roll of leather or paper cut to a point and used for shading. The result
was a highly finished imitation that looked remarkably like an indifferent photo-
graph.

Stumping was tedious to do and rarely produced a good, let alone a great,
draftsman. The one exception is Jean Dominique Ingres. Trained in the classi-
cal-academic method, his drawings (many of which are in lead pencil) repay
careful study. The amazing thing about them, however, is that they are so
much better than his paintings. While his drawings are visually strong, his paint-
ings are flabby.

Apart from this academic tradition, French drawing flourished with:

Honoré Daumier
Constantin Guys
Henri de Toulouse-Lautrec
Edgar Degas
Auguste Renoir
François Auguste Rodin
Théophile Steinlen

France, After 1900. After 1900, Paris attracted artists from all over the world. Many lived, worked, and died there. Among them, the notable draftsmen were:

Vincent van Gogh
Amedeo Modigliani
Chaim Soutine
Pablo Picasso
Jules Pascin

THE ORIENT

Drawing in China and Japan has always been an end in itself. At most, a drawing would be the basis of a woodcut or the decoration for a pot.

Brush and ink were most widely used on silk or paper, which would be either stretched on a screen or made into a scroll that could be unwound or hung on a wall when necessary.

Oriental philosophies have also influenced many modern attitudes to painting. The Zen principle of intuitive and spontaneous activity can be seen at its best in many Chinese and Japanese brush drawings.

Japanese art has had a great deal of influence in America, notably in architecture and in woodcuts, and the quick, lively marks of Japanese brush drawings have influenced American painting in no small way.

Some of these artists are:

Hokusai
Hiroshige
Sesshu
Sharaku

Indian, Persian, and Muslim Art. Very few Indian, Persian, or Muslim drawings survive. The Indians and Persians painted over their drawings and turned them into pictures. The Muslims were forbidden by their religion to create images and so concentrated on pure geometrical decoration. However, some of the Moorish pottery of Spain displays lovely brush drawings of animals and birds, and it is well worth observing.

UNITED STATES

Since the Second World War, American painting has dominated the international world of art. The trends set by Jackson Pollock, Franz Klein, Mark Rothko, and others have influenced painting throughout Europe. Yet this state of affairs did not come about purely by chance. On the contrary, it was the result of a growing tradition that began in the nineteenth century.

Yet though American painting is rich in outlook, thought, and culture, and though it is bought all over the world, few *drawings* by American painters exist.

But if American painters (and sculptors) are careless in preserving their drawings, those artists who sell their work to magazines are not. And we should turn to these artists to see American draftsmanship at its best.

In magazines like *The New Yorker, Esquire, Vogue*—to name only a few— vigorous, perceptive drawing is to be found on almost every page. Whether humorous or serious, these drawings represent varied styles and are a delight to look at. They should be studied just as carefully as drawings in an art gallery or museum—they possess those qualities that are to be found in the best drawings.

Many painters draw for magazines and advertisements without any perceptible change in their point of view. One of the best known is the late Ben Shahn, whose drawings, whether created as pictures or done for books, are always a joy to look at.

Other American artists include:

 Jack Levine

 Walt Kuhn

 John Marin

 Saul Steinberg

 David Stone Martin

From the nineteenth century:

 Mary Cassatt

 Thomas Eakins

 Albert Ryder

COLLECTING DRAWINGS

The works of all the artists listed above can be seen in museums and galleries, and furthermore they are quite often reproduced in books or magazines. These artists can therefore be easily studied.

As for the artists of our time, it almost seems that unless someone makes an attempt to collect their drawings, this will be another lean period. Artists are notorious for either wrapping parcels with their drawings or for giving them away free for the price of a beer.

Walter Sickert, a fine English draftsman, used to bundle up all his drawings from time to time, dump them on an unsuspecting dealer, and demand £5 for the lot. He often got it, too. If not he'd leave them, anyway. After all, they were only drawings—and he was finished with them. But now his drawings bring a very good price indeed.

The moral here is: Look around dealers' shops and try to get good drawings like those of Sickert's before they become permanently lost. You will not only do yourself some good, but the artist as well. By preserving someone else's work, you enrich your own.